ISAMBARD KINGDOM BRUNEL

THROUGH TIME

John Christopher

AMBERLEY PUBLISHING

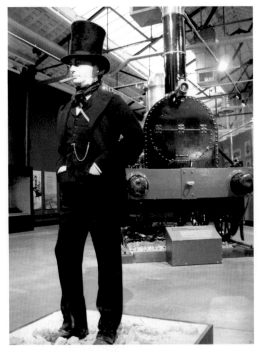

The illustrations in this book take the reader on a trip through the major works of Isambard Kingdom Brunel and they seek to document not only the changes that have occurred, but also to record its lasting impact upon the English landscape. As you will see, certain examples, such as the Chepstow railway bridge and the timber viaducts of Cornwall, have been lost or replaced by later structures, and of the three great ships, only the SS *Great Britain* has survived. Even so, there remains so much to be seen to this day, which, in itself, is a telling tribute to the legacy of Britain's greatest engineer. Hopefully this book will encourage readers to visit his works for themselves, but please note that in some cases, especially when it comes to the railways, access is sometimes restricted for reasons of safety.

First published 2010

Amberley Publishing Plc
Cirencester Road, Chalford,
Stroud, Gloucestershire, GL6 8PE

www.amberley-books.com

Copyright © John Christopher, 2010

The right of John Christopher to be identified as the Author of this work has been asserted in accordance with the Copyrights, Designs and Patents Act 1988.

ISBN 978 1 84868 963 3

British Library Cataloguing in Publication Data.
A catalogue record for this book is available from the British Library.

Typeset in 9.5pt on 12pt Celeste.
Typesetting by Amberley Publishing.
Printed in the UK.

Introduction

Isambard Kingdom Brunel. Even his name is on a monumental scale. The famous sepia-toned image of the figure in a stove-pipe hat and leaning against giant chains has become symbolic of the iron men who shaped our modern world. Although small in stature, just over 5 feet for the record, IKB stood head and shoulders above his contemporaries such was his energy, inventive vision and his ability to embrace innovation. Just look at the incredible leap of iron and faith between the wide span of Temple Meads' wooden roof, with its mock hammerhead beams, to the drama of the later Paddington station and its vaulted tracery of iron and glass. Without doubt, the Great Western Railway between London and Bristol can be regarded as Brunel's greatest and most enduring achievement, but he also built several magnificent bridges and even turned his hand to designing the first great ocean liners. Isambard Kingdom Brunel was a true polymath, the nineteenth-century equivalent of Renaissance man.

He was born in Portsmouth, on 9 April 1806, to an English mother, Sophia Kingdom, and a French father, Marc Isambard Brunel, who had fled the turmoil of revolution in his native land, initially to the USA and then to England. Marc was an accomplished engineer and inventor in his own right and most notably had pioneered machinery for the mass-production of ship's pulley blocks for the Admiralty. So it was beyond doubt, right from the outset, that his one and only son would follow in his footsteps.

As is so often the case, timing was everything in Brunel's life. He grew up in the final decades of the Georgian era, a world in which the seeds of the industrial age had been sown, but had yet to assume the whirlwind of a full-blown revolution. In 1825, his father became engineer to the Thames Tunnel, an ambitious project to bore through the soft clay and unstable gravels beneath the river to provide access to new docks south of the Thames. Marc devised a tunnelling shield which

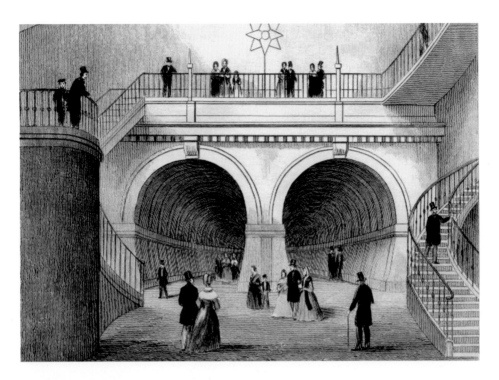

The Thames Tunnel

The young Isambard cut his engineering teeth on the Thames Tunnel working under his father, Marc Brunel. Started in 1825, it had been intended to accommodate horse-drawn vehicles taking goods from the docks into the city, but funds ran out before the larger access shafts with ramps could be constructed. Finally opened in 1843, it was for pedestrians only at first, then, in 1865, it was adapted for rail use. The twin horseshoe entrance is still visible from the narrow platforms of Wapping Underground station.

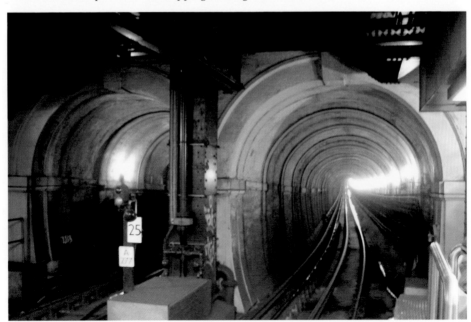

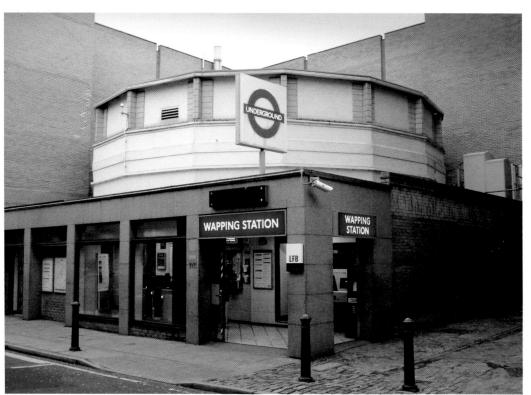

Wapping and Rotherhithe

At Wapping, one of the original shafts for the Thames Tunnel has been incorporated within the tiny station building and its capped top rises above the booking hall. On the Rotherhithe side of the river, there is the red-brick building which housed the steam engine to pump water out of the workings, and this has been restored to create the Brunel Engine House Museum. Just a few feet away, the Rotherhithe shaft has recently been sealed off at the bottom to provide additional exhibition facilities.

consisted of a series of vertical iron frames to accommodate thirty-six miners who were faced by rows of removable wooden slats. Once the excavations had been completed for each frame, it would be shunted forward by hydraulic jacks and bricklayers built the tunnel walls in the gap. In theory the shield protected the workforce as they dug, but progress was desperately slow and it was arduous and dangerous work with the tunnel flooding on several occasions. In failing health, Marc appointed his twenty-year-old son as resident engineer, and Isambard threw himself heart and soul into the task.

Brunel was very much a hands-on engineer, and on the morning of 12 January 1828, he was working at the shield when a torrent of freezing water burst into the workings with a sound like thunder. The rush of water was so strong that he was carried up to the lip of the shaft where he was plucked to safety. Six of the workmen died that day and Brunel sustained serious injuries. The breach was filled with clay, but with dwindling financial resources, the project had to be abandoned, and when work resumed in 1835, it was without Brunel. The tunnel was finally opened to the public in 1843, but lacking the access shafts and ramps for horse-drawn vehicles, it was only suitable for pedestrians. In 1865, it was sold to the East London Railway.

Following the 1828 accident, Brunel went to Brighton, and then on to Bristol, to recuperate. This hiatus in his career was made all the more gruelling by the successes of his contemporaries, especially his close friend Robert Stephenson, but timing was on Brunel's side and the Bristol connection proved to be the turning-point. Firstly, there was the competition to design a bridge across the Avon Gorge at Clifton, and as a result of his many new contacts, he was appointed to survey the route for a railway between London and Bristol. The rest, as they say, is history.

We are fortunate that so much of Brunel's work has survived and we can see first-hand how he combined engineering genius with great artistry. A hard taskmaster, or in modern parlance, a control freak, Brunel oversaw the minutest detail of every project, and the results are not just functional, they are artistic statements on a grand scale. As the historian and broadcaster Dan Cruickshank put it, Brunel was 'a one-man industrial revolution'.

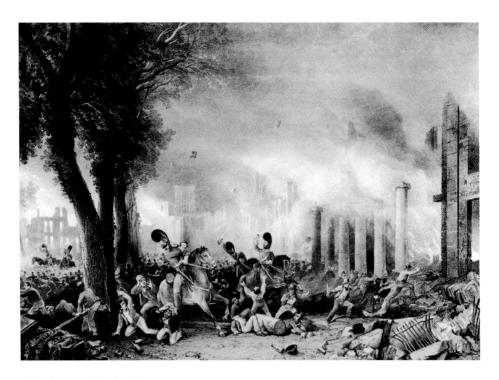

Bristol was a riot in 1831

It is not clear what drew Brunel to Bristol originally. Possibly to recuperate, or perhaps it was the competition to design the Clifton Bridge. Shortly after work had commenced on the bridge, the city was overrun by rioters opposed to the Reform Bill. Brunel immediately enrolled as a special constable, and as the mob ransacked the Mansion House in Queen Square, he made an arrest. Following rebuilding, the square remains as one of Bristol's most attractive public spaces.

Railways

Apart from gaining Parliamentary assent, the building of the early railways was entirely unregulated, and for Brunel, this meant a blank canvas on which to create the 'best of all possible railways'. The first decision was the choice of route. At 118 miles long, the 'Bristol Railway', as it was originally known, would be the longest railway in the country. Instead of a 'southerly' route, going from Bath and passing through Trowbridge, Devizes and Hungerford to join the Thames Valley at Reading, Brunel favoured one which curved northwards from Reading to Didcot and across via Chippenham to Bath. Although criticised for passing through too much empty countryside, it did have the potential for future connections with Oxford, Gloucester and Cheltenham. It was also very level, with an average gradient of only 4 feet per mile for the first fifty miles and, accordingly, it became known as 'Brunel's billiard table'.

Going back to first principles, Brunel settled upon a broad gauge with the rails 7 feet apart. This, he argued, would give a more stable ride than the existing gauge of just over 4 feet and allowed for the possibility of the carriages sitting within larger wheels. Furthermore, his rails would run on wooden longitudinal members, linked with cross-members every 15.5 feet, standing on timber piles. In practice, this arrangement caused the track to dip between the piles under the weight of the trains and it was re-laid on conventional ballast. As for the locomotives, Brunel's initial specifications proved entirely unworkable, and in 1837, Daniel Gooch was appointed as the GWR's locomotive superintendent.

As construction of the line progressed, Brunel and Gooch selected the Wiltshire town of Swindon as the site for the GWR's locomotive works. The western section of the line proved far more challenging and included the two-mile tunnel through Box Hill between Chippenham and Bath, and a series of further smaller tunnels, cuttings and embankments between Bath and Bristol. It culminated with Brunel's magnificent Temple Meads station, which, with its wide wooden roof, survives as the earliest purpose-built railway terminus in the world. Brunel was involved in every aspect of the railway's design and demonstrated a deft hand in the architecture of the station buildings. For the smaller ones, he devised a standardised design known as the 'Pangbourne' type, and for the most part, the main stations were in the Italianate style or dressed as Tudor farmhouses. It was only because the original Paddington station had been a temporary structure that Brunel was able to take advantage of developments with new materials to create the radically different iron and glass roof for its successor.

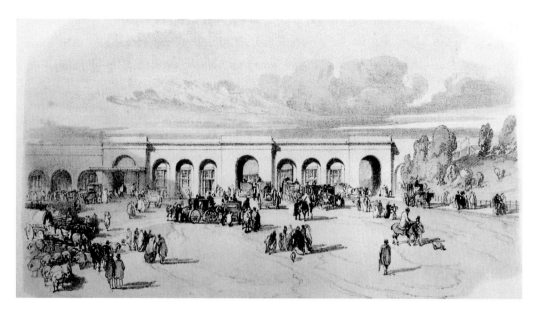

Paddington

Bourne's engraving of the original station at Paddington, opened in June 1838, reveals an unimposing wooden building which was intended only as a temporary structure following the collapse of talks to share facilities with the London & Birmingham Railway.

The art and science of photography only came into wider use later in Brunel's career, and, subsequently, we have no photographs of the early stages of the GWR's construction. What we do have, however, is a series of superb lithographs by the artist John Cooke Bourne. As he put it in the preface to *The History and Description of the Great Western Railway*, 'The difficulties to be overcome in the construction of the railway, and the great capital employed in overcoming them, have given rise to a number of engineering works of the highest class, both as examples of constructive skill and general grandeur of appearance.'

As engineer of the GWR, Brunel had a monopoly on the various extensions and branch lines: westwards through Devon and Cornwall, across South Wales, north to the south Midlands and southwards towards the coast. These, naturally, were all constructed to his broad gauge – although particular mention must be made of the atmospheric principle Brunel adopted for the South Devon Railway. Unfortunately, his broad gauge lost out through sheer weight of numbers to the so-called 'standard' gauge and conversion of the tracks was completed by May 1892.

Undoubtedly, the railways had an unprecedented and profound impact on the Victorian world. When Brunel was born in 1806, they didn't exist, and yet by his death, in 1859, the network of rails had spread throughout the land, and in no small part thanks to his involvement. The GWR has often been referred to as 'God's Wonderful Railway'. Its detractors might have preferred the 'Great Way Round', but they are not many.

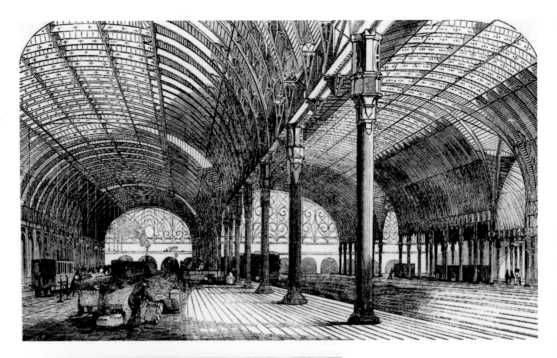

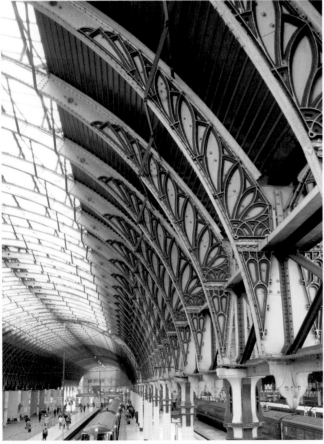

Brunel's greenhouse
In 1848, Brunel designed a new station for the enlarged site at Paddington. In essence, this was a cutting with no real exterior, and accordingly he created a magnificent roof of iron and glass. Modestly decorated arches support three main sections 700 feet long, which are punctuated by two crossways transepts.

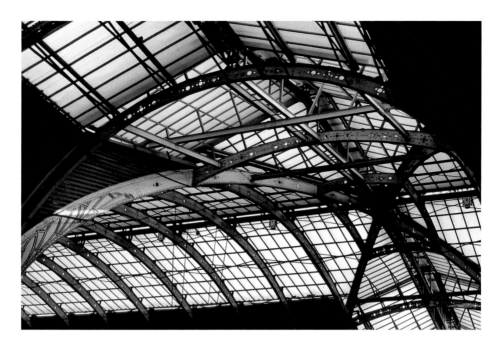

Paddington's iron and glass roof

The main sections of the station's roof consist of wrought-iron beams spaced 10 feet apart and supported by cast-iron columns every 30 feet, leaving the middle two 'floating' arches resting on the cross-bracing. The intersection with the crossways transepts, at one-third intervals lengthwise, creates an intricate geometry with a superb web of curving girders. To carry out much of the decorative treatment, Brunel recruited the architect Matthew Digby Wyatt, and his hand can be seen in the delicate tracery of the glazed gables at the 'country' end of the station.

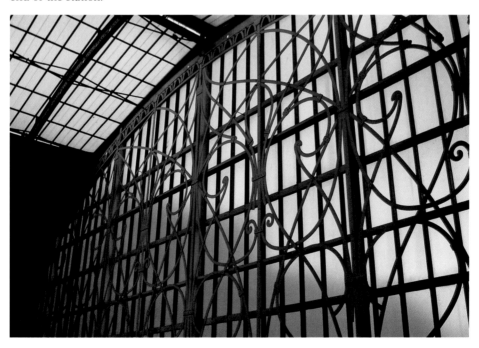

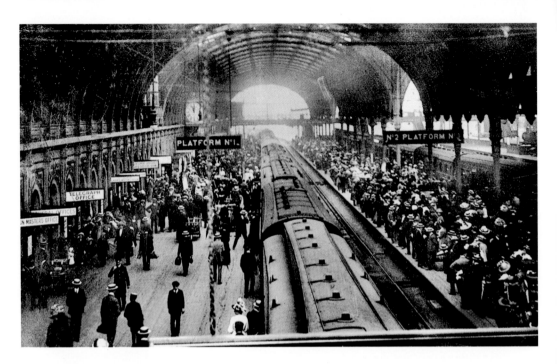

Paddington Station

With its links to Windsor and Eton, Paddington's platforms frequently swarmed with straw-hatted schoolboys in Edwardian times. Today, it remains a vibrant London terminus with fourteen platforms serving First Great Western's trains to the West Country, West Midlands and South Wales. The concourse area situated at the 'town' end of the station is still known as 'The Lawn' and has been transformed into a modern glass-walled quiet zone for travellers amid the hubbub of this busy station.

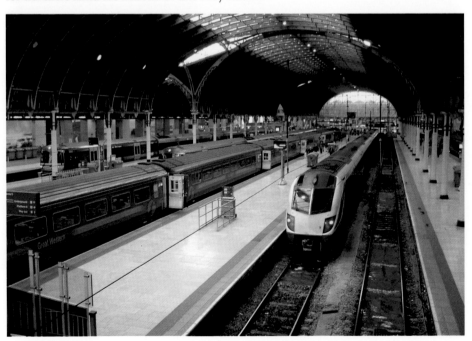

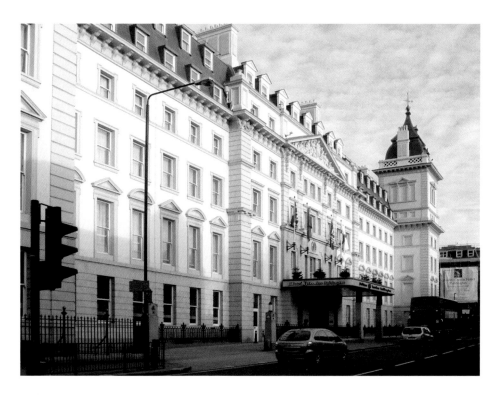

Paddington Hotel

In many respects, Paddington Station is a building with no recognisable outside. The nearest thing to a frontage is probably the Great Western Royal Hotel on Praed Street. This imposing building, in the Second Empire style with its tall corner towers, was designed by Philip Charles Hardwick and opened in 1854. Although it was managed separately from the railway initially, Brunel was the first chairman of the board. Refurbished in the 1930s, it is now the Hilton London Paddington.

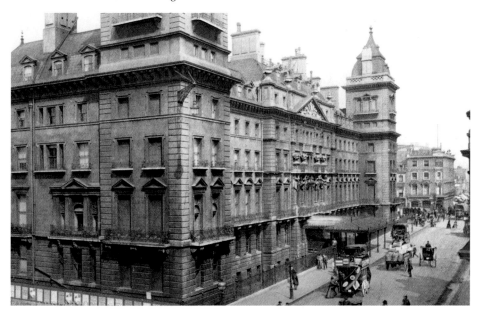

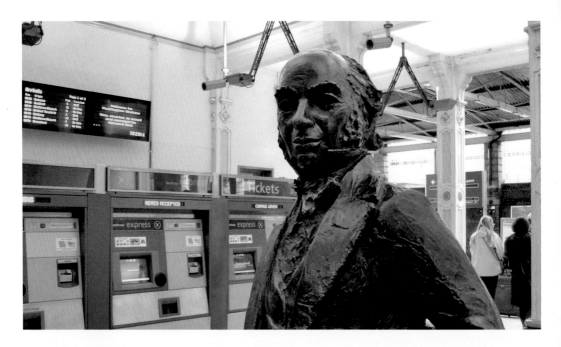

Paddington today

Sculptor John Doubleday's seated statue of Brunel now resides at the taxi entrance to Platform 1, although many tourists are more interested in the one of Paddington Bear on the main concourse. The station was substantially enlarged between 1906 and 1915, including the addition of the 109-foot fourth span. Of steel construction and largely echoing the original three spans, although lacking their crossways transepts, it was under threat to create space for London's new Crossrail line but has now been saved from demolition.

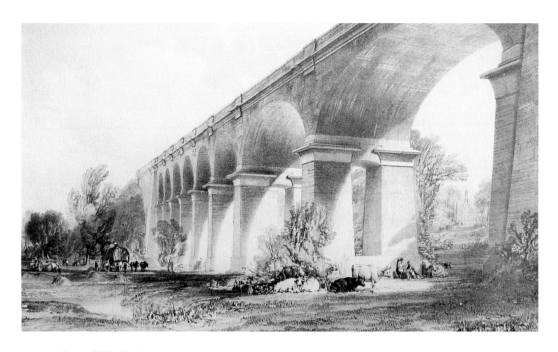

Wharncliffe Viaduct

To cross the Brent Valley on the western side of London, Brunel created the Wharncliffe Viaduct. At almost 900 feet long, it is the largest brick-built structure on the GWR and consists of eight semi-elliptical arches mounted on elegant tapered piers with sandstone cornices. Stylistically, it evokes the Egyptian influences repeated on his bridge at Clifton. As part of the scheme to increase the railway from two broad gauge tracks to four standard gauge, the viaduct was widened by adding a third row of piers in 1877.

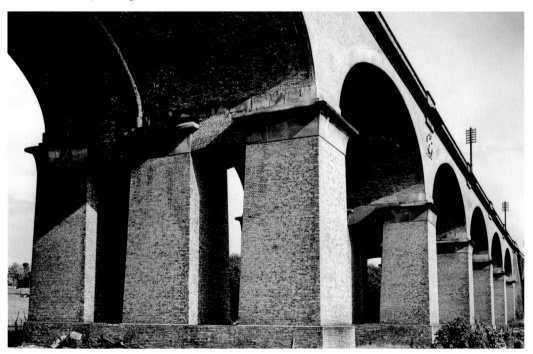

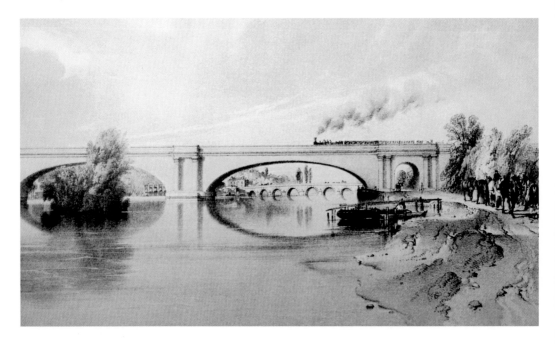

Maidenhead's wide arches

The Thames presented a major obstacle to the GWR's western progress at several locations, and at Maidenhead in particular, the challenge was to create a crossing with only a single central pier standing on a shoal mid-stream. Undaunted, Brunel's daring solution was to create a bridge with two 128-foot arches, the widest and flattest brick-built arches ever seen. A pair of smaller semi-circular arches connects with the railway embankment at either side. In Bourne's contemporary engraving, a broad gauge train is seen crossing the bridge, and the older road bridge is visible just to the north. Despite its many detractors and sceptics, Brunel's great brick bridge at Maidenhead has stood the test of time.

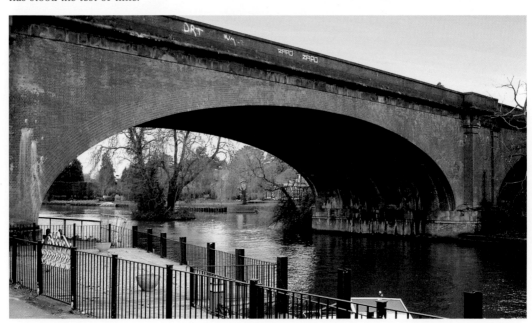

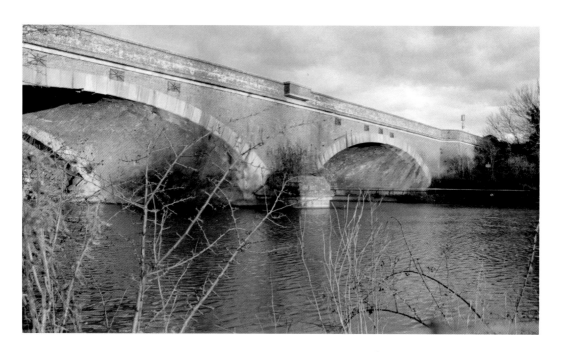

Widening the bridges

West of Reading, the railway crosses the winding Thames on another two major brick bridges at Basildon and Moulsford, shown above, where the latter cuts the river at an awkward 45 degrees. Fortunately, a footpath at Moulsford provides a close-up view of this masterful piece of construction work with the twisting brick arches describing their compound curves. You can also see where the bridge was widened in the 1890s to accommodate two additional tracks. The image below shows widening work being conducted on the Maidenhead Bridge between 1890 and 1893. (STEAM Museum of the GWR)

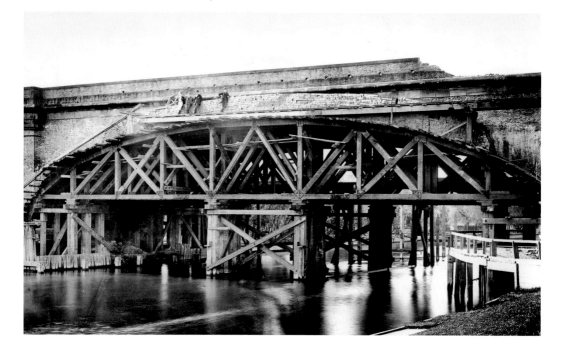

Brunel's broad gauge
Little remains from the broad gauge days. At its preservation centre at Didcot, the GWR Society has recreated a short section of the mixed-gauge track which accommodated both types of trains. Mixed-gauge was introduced to solve the incompatibility problems between the two systems, but was only seen as a temporary fix. In its heyday, the broad gauge enabled the development of some formidable locomotives, such as this B&ER locomotive No.44 of 1845 with its 9-foot driving wheels.

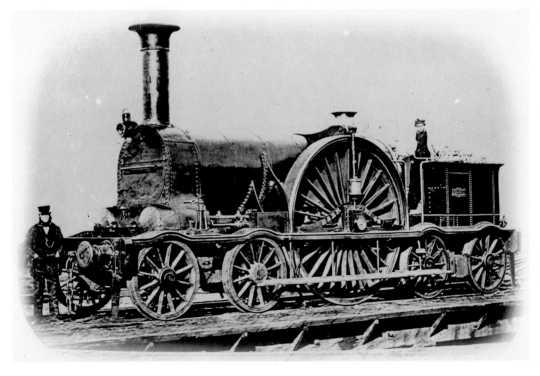

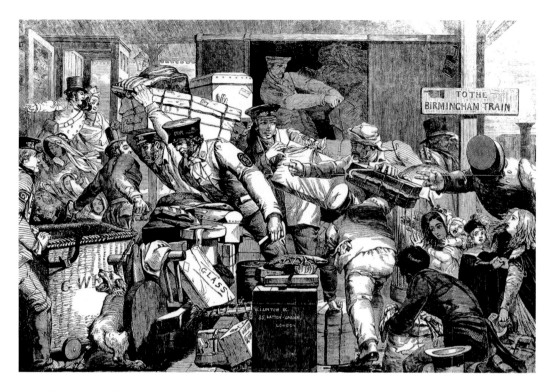

The 'break-of-gauge' problem

The wider gauge was undoubtedly superior to the so-called standard gauge, but inevitably, conflicts occurred where the two met head-on, and by 1845, there were ten such places. This contemporary engraving depicts the chaos at Gloucester as passengers and goods swap trains. Transfer sheds, like this example at Didcot, had broad gauge tracks on one side and standard on the other.

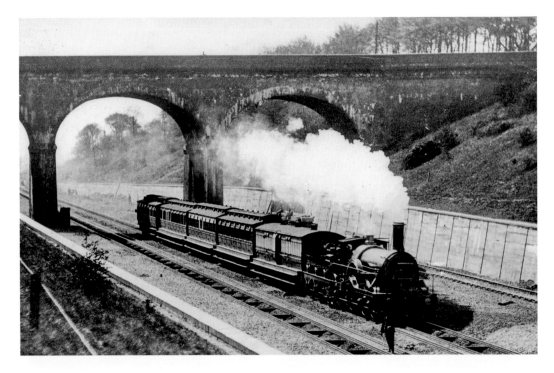

Sonning cutting

Initially, Brunel had wanted to drive a tunnel through the high ground at Sonning, on the eastern side of Reading, but he decided upon a deep cutting instead. The result is a two-mile swathe through the landscape, varying in depth from 20 feet to 60 feet, excavated by an army of 1,200 navvies. In May 1892, the very last broad gauge train paused at Sonning for a photograph, shown above, as it made the final westbound journey. The scene has hardly changed.

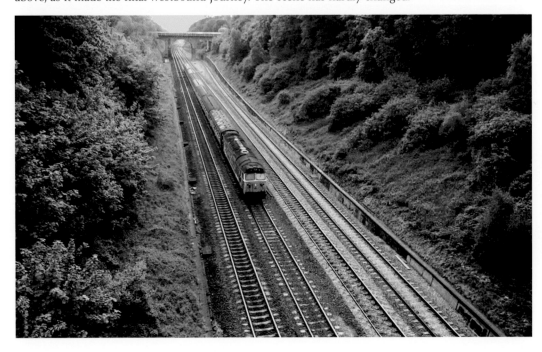

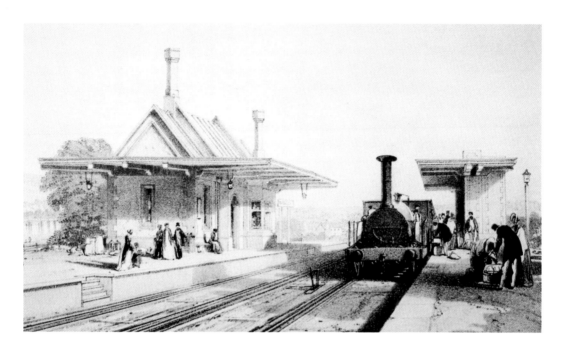

Stations

For the smaller or 'secondary' stations on the GWR, Brunel produced a simple, standardised, single-storey design known as the 'Pangbourne' type. J.C. Bourne made this engraving of Pangbourne Station complete with broad gauge locomotive. Note the absence of safe crossing facilities for the passengers, a common and dangerous shortcoming with many early station layouts. The photograph of the station at Culham, on the Didcot to Oxford line, reveals a carbon copy complete with Brunellian features such as the skewed chimneys. It has been restored and now serves as an office space.

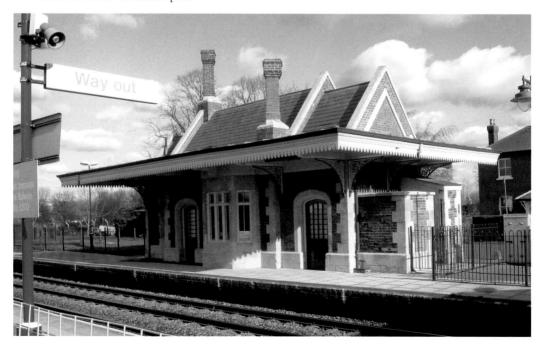

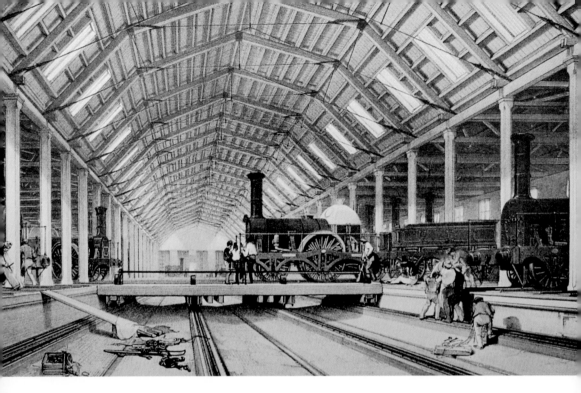

Swindon Works

The selection of Swindon as the GWR's engineering centre transformed this sleepy Wiltshire settlement into a railway town, boosting its population from 2,000 in 1800 to 45,000 by the end of the century. Swindon Works grew quickly and Brunel's wooden engine shed was swept away in the 1920s to make way for newer workshops. At its peak in the early twentieth century, the works occupied 320 acres of land. A King Class boiler is shown being lowered on to driving wheels in this 1927 photograph of the Erecting Shop. (STEAM Museum of the GWR)

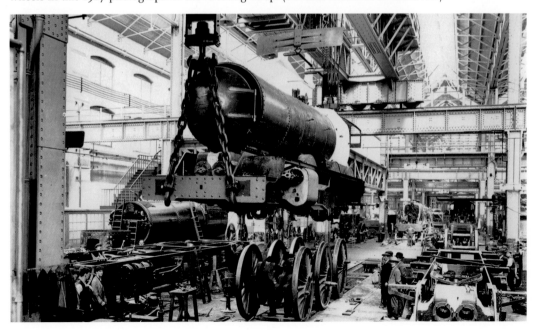

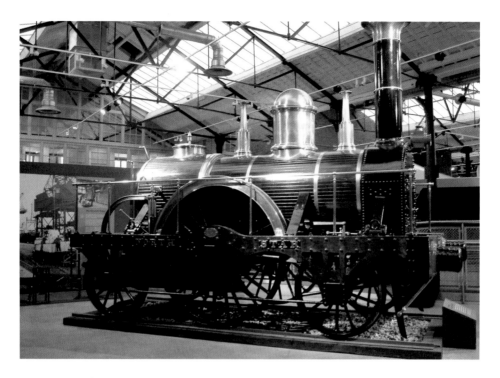

Broad gauge locomotives

The company's first successful locomotive, *North Star*, was produced by Robert Stephenson's Newcastle company. This replica, built to mark the GWR's centenary, is displayed at the STEAM Museum, but only the driving wheels are from the original. At Didcot, the GWR Society has created a working replica of the *Fire Fly*.

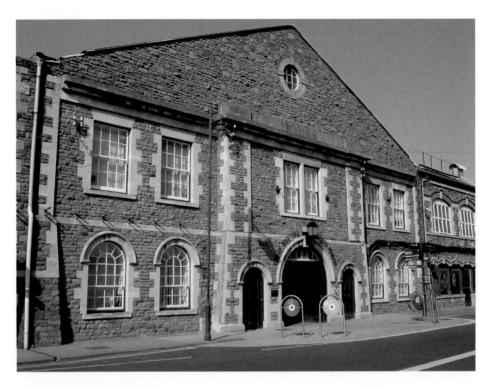

Swindon Railway Village

Working for the GWR was more of a way of life than just a job. The works stand cheek by jowl with the Railway Village where 300 company houses are laid out in neat rows along six streets. Conceived by Brunel and designed in collaboration with Matthew Digby Wyatt, they were built between 1841 and 1865.

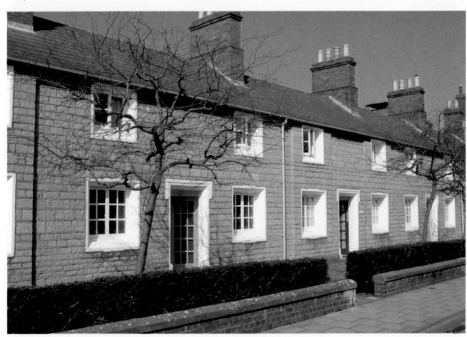

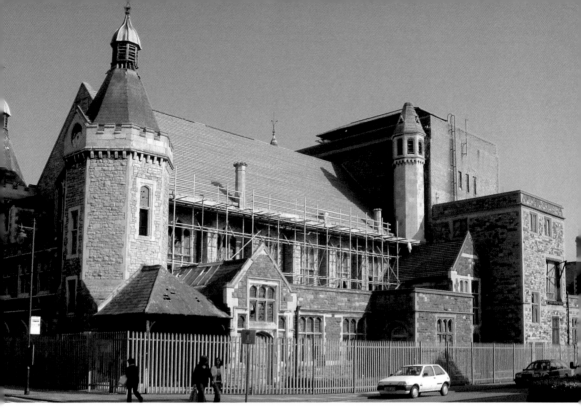

A railway community

The GWR provided for more than just housing. At the heart of the village is the Mechanics Institute, which housed a library, theatre and games room for the company's employees and their families. The twin-spired building facing on to Farringdon Street was a lodging house for the single men.

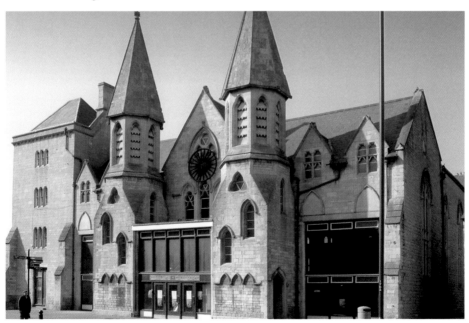

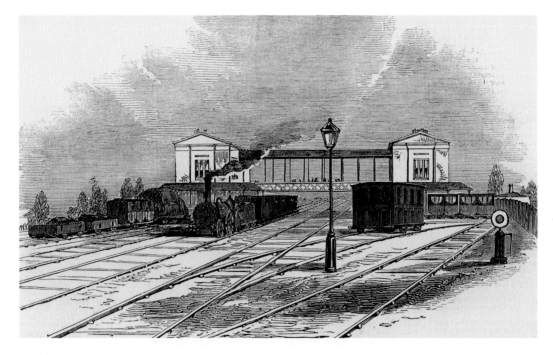

Swindon Junction

The GWR's station at Swindon opened in 1842 and, as a result of a notorious contractual agreement with the company that supplied over-priced refreshments at the station, all trains were required to stop here for ten minutes until 1895. It was known as Swindon Junction after the branch line to Cirencester opened, and also to avoid confusion with the Swindon Town Station serving the Midland & South Western Junction Railway on the other side of town. In this photograph from around 1890, a London-bound train can be seen riding on mixed-gauge tracks. (STEAM Museum of the GWR)

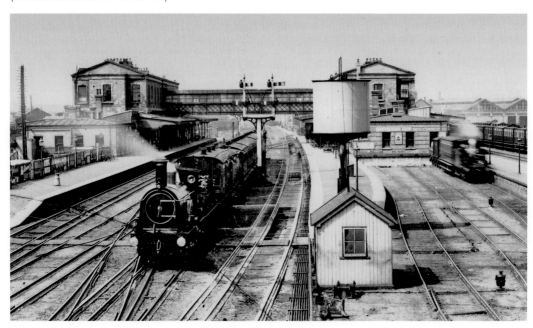

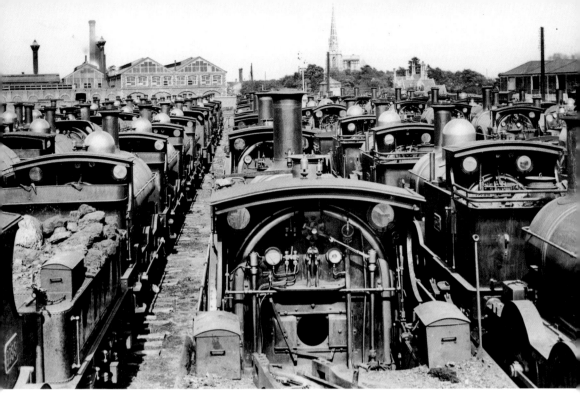

Swindon's locomotives

In 1892, Swindon Works became a graveyard for redundant broad gauge locomotives awaiting scrapping (STEAM Museum of the GWR). Despite the setback, the company's prestige was soon in the ascendency again with the likes of the Castle and the King Class locomotives. The first of the 6000 or King Class was the *King George V* of 1927, shown here on display at the museum in Swindon.

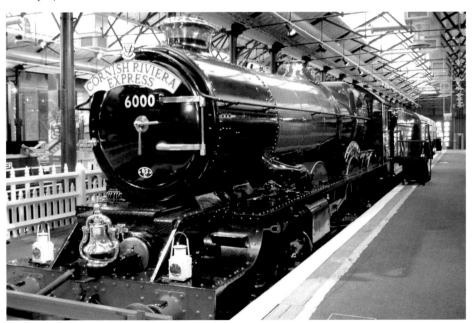

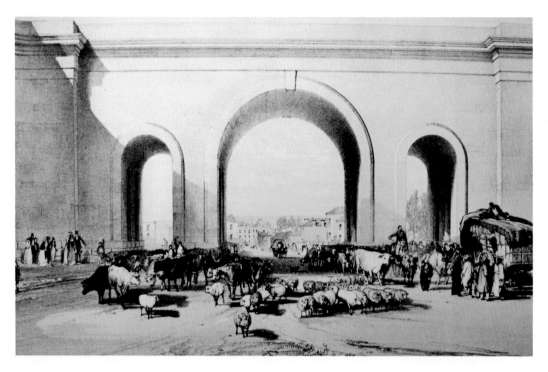

Chippenham viaduct

Arguably the most striking landmark in the town, the viaduct which strides through Chippenham has the feel of an ancient gateway, and indeed Bourne's exaggerated use of scale reinforces this impression. Clad in mellow stone on the north outward-facing side, and in dark brick on the other, it remains little changed apart from the ubiquitous road traffic.

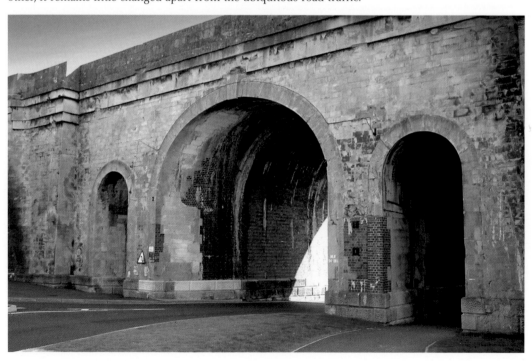

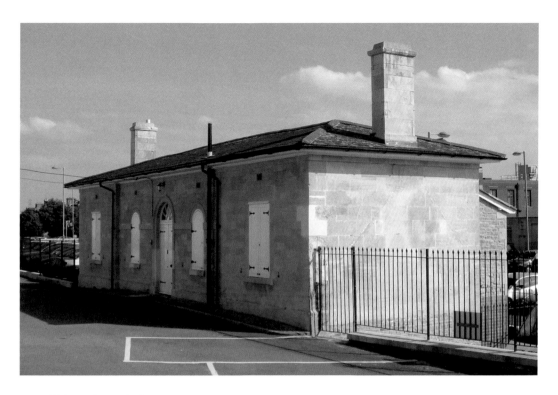

Chippenham station

The town's role as a regional centre of agriculture and industry made it a busy destination for rail traffic. The large goods shed has gone, but the Regency-style station building remains, albeit largely hidden by the extensive canopies. Of particular interest is this detached single-storey building, said to be Brunel's office during construction of this section of the railway.

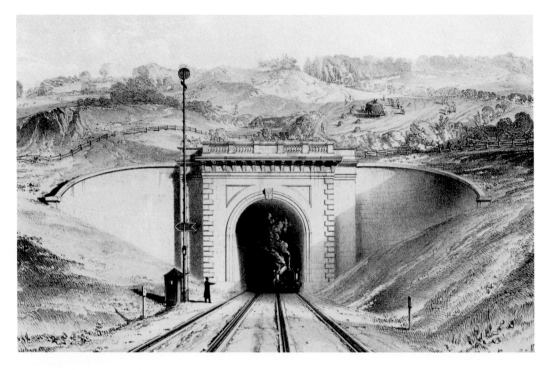

Box Tunnel, west portal

Box Hill, located between Chippenham and Bath, presented a formidable obstacle, and for Brunel, the only way through would be with a tunnel nearly two miles in length. Dead straight, it descends from the east with an incline of 1 in 100. Construction began in 1836 and excavations continued day and night with as many as 4,000 navvies continuously employed. By the time it opened in June 1841, it had cost the lives of around 100 of them.

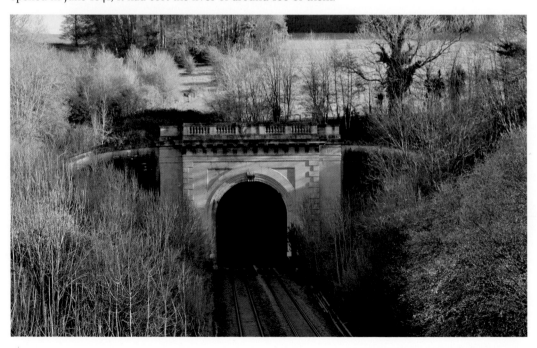

Building the tunnel

The method of construction was to sink eight vertical shafts, each approximately 25 feet in diameter and from 70-300 feet in depth, to provide access and ventilation. From the bottom of the shafts, the navvies began excavations in both directions, hoping that they would eventually join up. In some places, they encountered hard limestone which they had to blast their way through, while in others, thousands of bricks were used to hold back the clay and fuller's earth. Six of the shafts still serve to ventilate the tunnel, and although they are all located on private land, you can spot them on Google Earth.

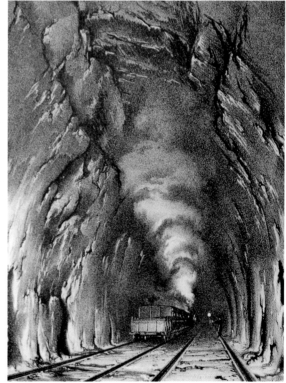

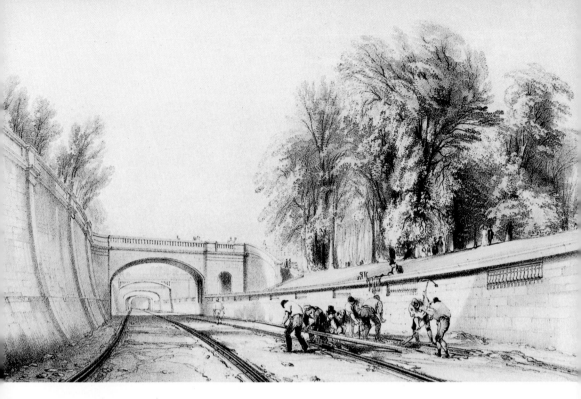

Sydney Gardens, Bath

Entering Bath, the railway passes through Sydney Gardens via a long cutting into the side of the hill. Far from spoiling the scene, the locals proclaimed that the new line actually added to the attraction of the gardens. Certainly, the curving retaining wall, elegant bridges and low balustrade, make it one of the most photogenic locations on the old GWR. As can be seen, the level of the railway itself has risen several feet since Bourne depicted the scene. As a result, the London-bound trains hurtle past alarmingly close to any onlookers.

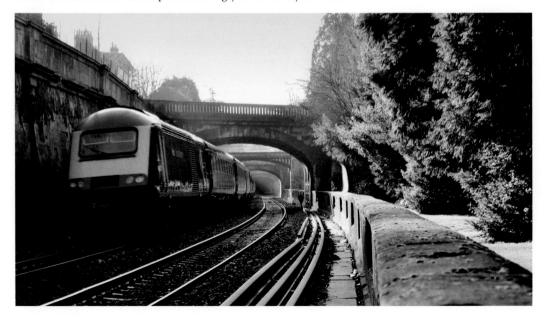

St James's Bridge and arrival in Bath

Beyond Sydney Gardens, the trains pass under the Georgian houses via several short tunnels, and after emerging on a raised section, they approach Bath Station on the 88-foot span of St James's Bridge which passes over the River Avon. The station itself is situated in an awkward site, tucked into a corner of land within the elbow of the river.

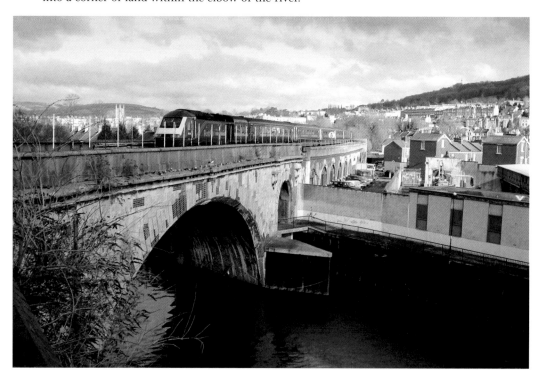

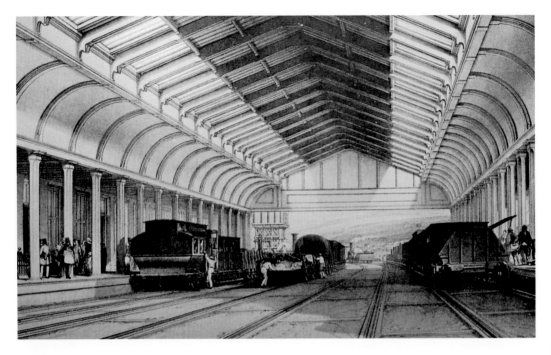

Bath Station

Brunel had designed Bath Station with an all-over wooden roof structure, as was his custom with the more important mainline stations. Sadly, the roof and supporting columns shown in Bourne's engraving have long gone. As a result, the station now seems much wider, especially as the original four broad gauge tracks have been reduced to only two, leaving a wide central space. The later platform canopies tend to obscure the station building, but the view of the hills to the east remains much the same.

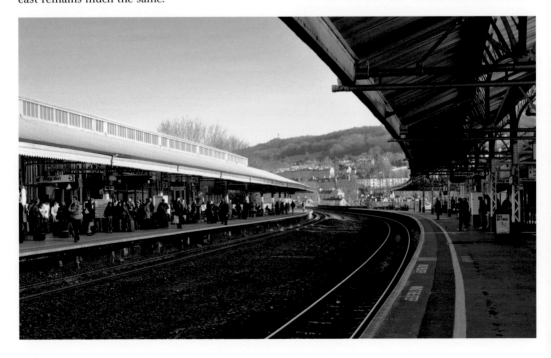

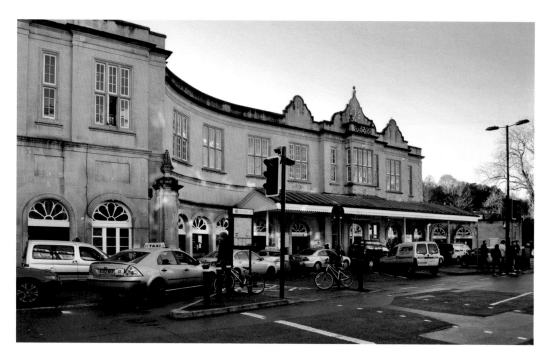

Bath Station

At odds with its location in this celebrated Georgian city, Brunel chose an Elizabethan farmhouse style for the station's exterior. The illusion goes further, as the upper storey is in fact the platform level while the ground floor is occupied by the booking hall. In the lower image from 1950, it has been decorated for the visit of HRH Princess Elizabeth. Note the blackened Bath stonework, characteristic of the town's buildings at the time. (STEAM Museum of the GWR)

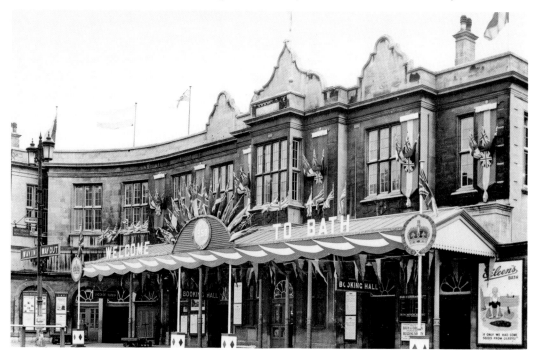

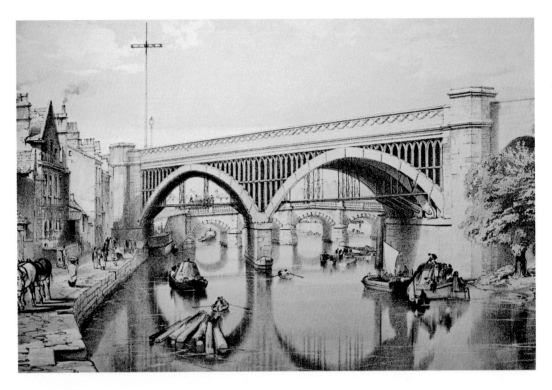

Skew bridge over the Avon at Bath

Immediately to the west of Bath Station, the railway crosses the River Avon once more, and this time at an awkward angle. With funds running low, Brunel devised a two-span bridge structure built of laminated wood. Each span of 80 feet consisted of six ribs, in-filled with ornamental ironwork, standing on masonry abutments and a central pier. Inevitably, the wood did not last and his bridge has been replaced by the functional trussed steel structure seen today.

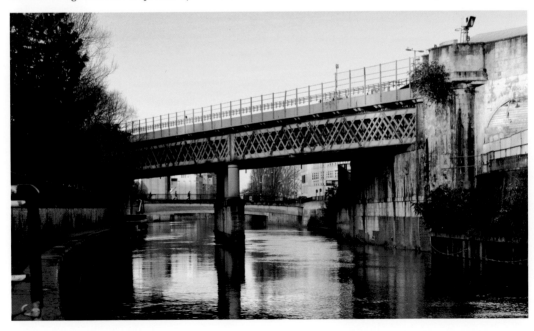

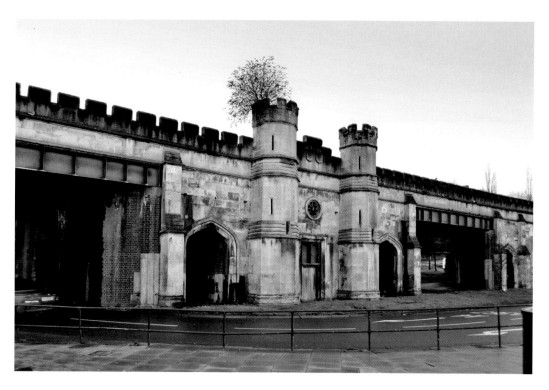

Westwards through Bath

Leaving Bath Station and continuing towards Bristol, the railway line is carried aloft on a long low-level viaduct running to the south of the river and roughly parallel to the A4 road out of Bath. A fine crenellated section, complete with mock castle towers and decorated with the GWR London/Bristol coat of arms above a locomotive wheel motif, still spans the busy A4/A367 roundabout beside the Bath road bridge.

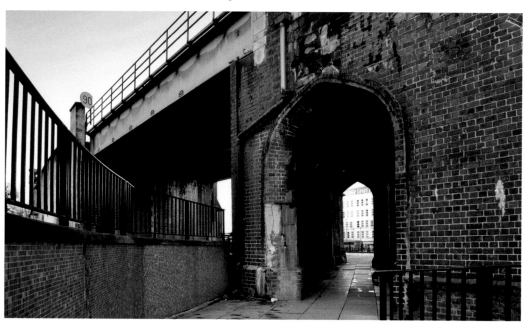

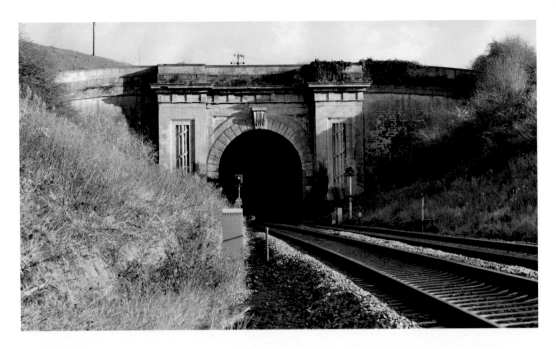

Tunnel vision

The undulating terrain on the final leg of the railway westwards required a series of cuttings, embankments and tunnels, the latter in particular allowing Brunel to indulge his taste for elaborate decoration. Less than a mile from Box is the much-overlooked Middle Hill Tunnel; only 600 feet long, its grandeur is overshadowed by Box Tunnel. On the edge of Bath, the Twerton Tunnel displays a fine crenellated tower on its western portal, clearly visible from the A4.

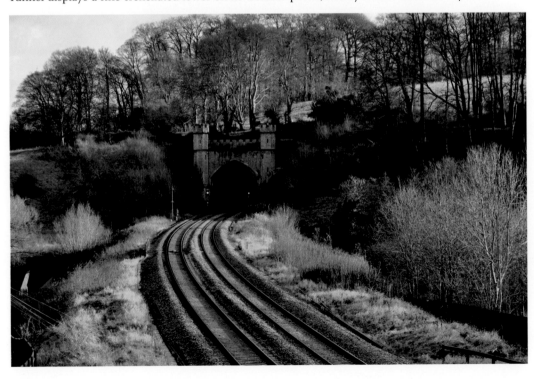

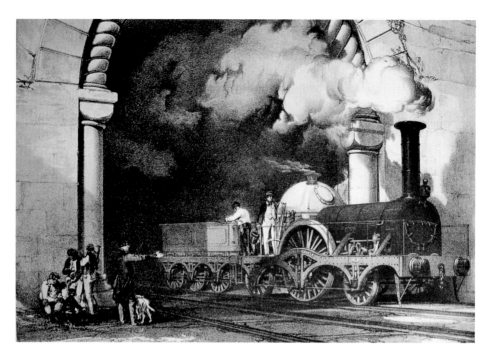

Towards Bristol

There are a number of further tunnels between Bath and Bristol, including one at Saltford. Finally, as the railway line hugs the valley bottom around Brislington and then curves into Bristol, there are three tunnels numbered from east to west. These include Number 1 Tunnel, so famously depicted by J.C. Bourne with an emerging Fire Fly Class locomotive on the frontispiece to his 1846 *History and Description of the Great Western Railway*, and Number 2 shown below.

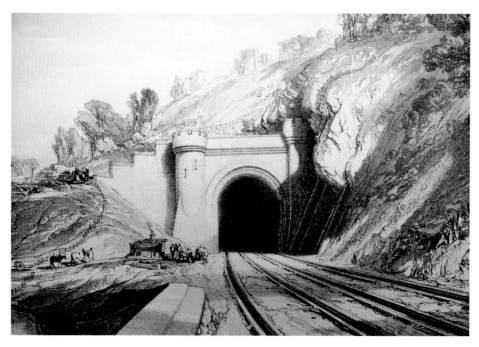

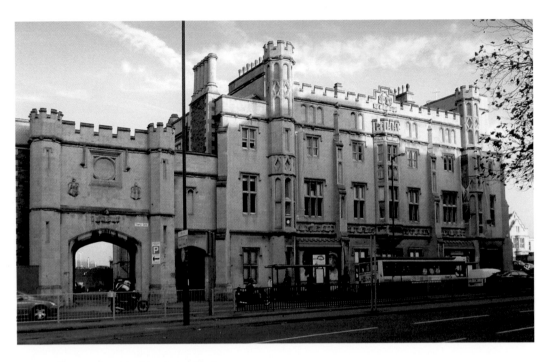

GWR offices at Temple Meads, Bristol

Brunel's Tudor-style façade for the offices of the Bristol directors of the GWR still survives. Abutting the terminus buildings, it originally had an arch either side and carriages would enter through the left-hand side, pass under and through the station to emerge and exit on the other side. Note the company coat of arms above the remaining arch, and the circle where a clock would have shown railway time. The other arch was demolished to widen the approach road.

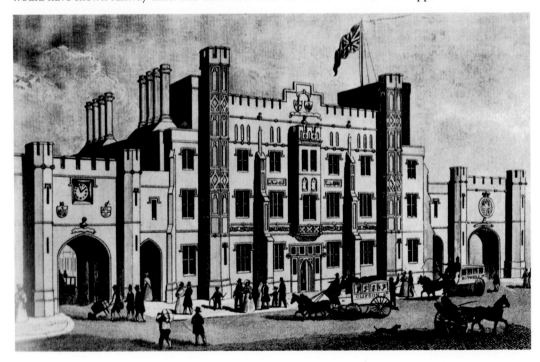

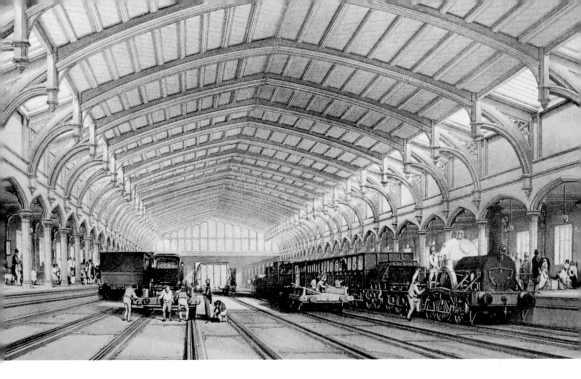

Temple Meads station

Probably Bourne's most famous engraving of the GWR shows the interior of Brunel's Passenger Shed, which opened in 1840. The windows to either side were unglazed originally and further ventilation was later added to the roof for steam and smoke to escape. Despite extensive expansion of the station during the 1870s, Brunel's building remained in use until the 1960s, but subsequently it was relegated to use as a car park with the platforms still in situ, and by the time of this 1970s photograph, its condition was deteriorating.

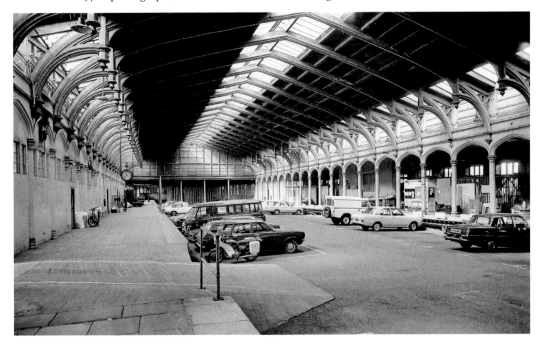

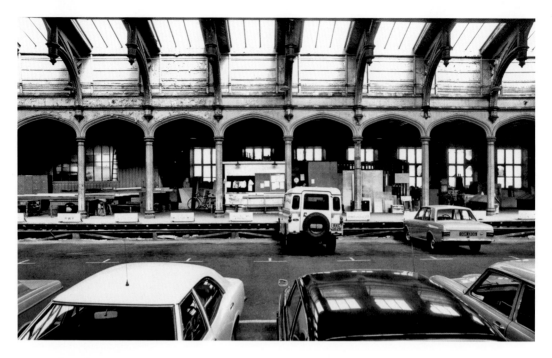

Disuse and disrepair

By the 1970s, the original Temple Meads buildings were in a poor state. The lower image shows the Engine Shed, sandwiched between the Passenger Shed and the offices. Brunel's terminus was a dead end and the locomotives were rotated on a turntable to point them back the other way. Openings between the tracks allowed for the disposal of ash and clinker down to trucks in the vaulted cellars. Today, it is occupied by the Empire & Commonwealth Museum, and apart from the support columns, little evidence remains of its former use.

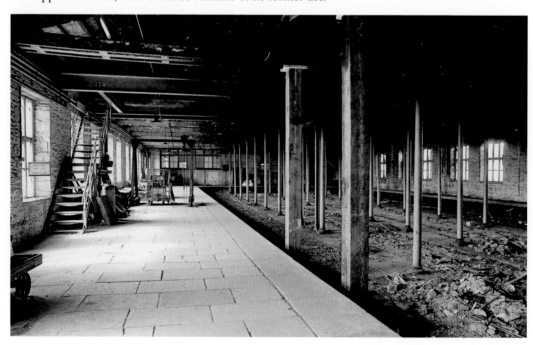

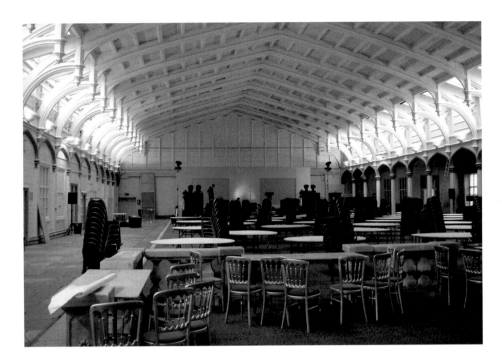

The restored Passenger Shed

Temple Meads is the oldest purpose-built railway terminus in the world and, thankfully, by 1983, which was the 150th anniversary of Brunel's appointment as engineer to the GWR, plans were afoot to rescue the buildings. Today, the magnificent Passenger Shed serves as a venue for conferences and exhibitions. The wooden roof was the widest in the world at the time of its construction and travellers marvelled at its 74-foot span. The distinctive hammerhead beams look impressive, but they are purely for decorative effect.

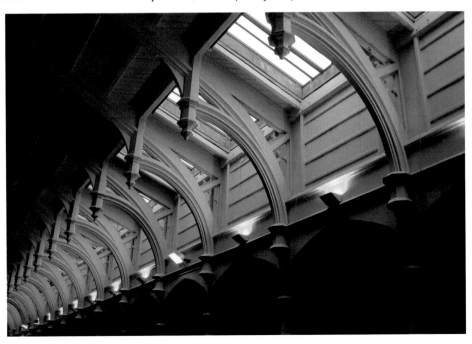

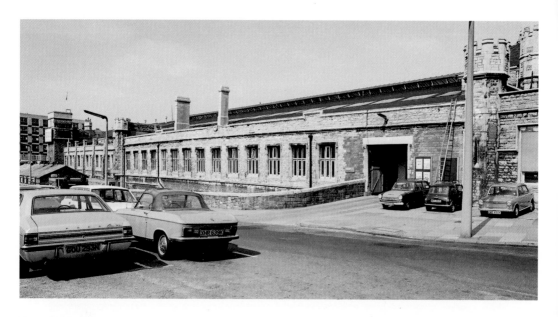

Temple Meads

This 1970s photo of the exterior of Brunel's Temple Meads shows the rear of the offices to the far left, the Engine Shed, and then the Passenger Shed with a modern vehicle access on the right. The tall box-like structure above the offices is a water tower which supplied the locomotives in the Engine Shed. As part of the expansion of the station in the 1870s, Brunel's platforms were lengthened by more than 600 feet with a brick-built extension, shown below. At the end where it adjoins the original Passenger Shed, two bays of the hammerhead roof remain in an unrestored condition. Cut off from the rails by later building work, this space is currently used for parking. Note the wooden structure protruding from the wall to the left. This used to be a signal box.

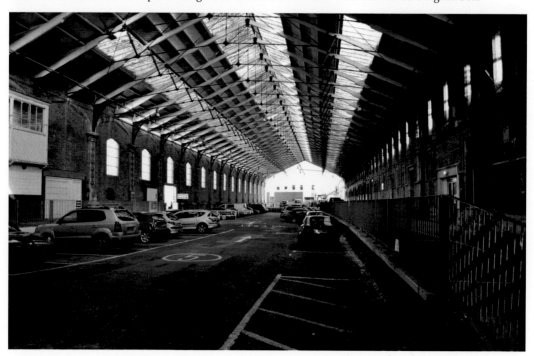

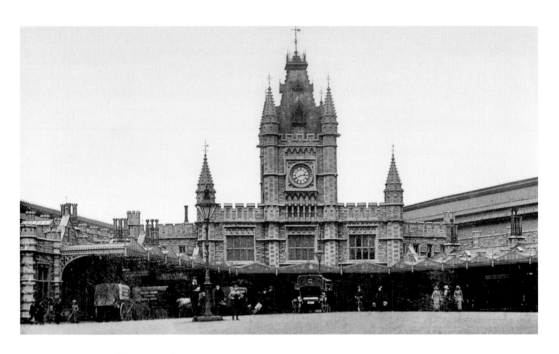

Temple Meads approach

The enlargement of Temple Meads in the 1870s sidelined the old terminus by creating a three-platform through-station fronted by a striking new main entrance in a full-on Victorian Gothic-style. The design of the new station has often been attributed to Brunel's former collaborator Matthew Digby Wyatt, but it is more likely to be the work of Francis Fox, who was the former engineer to the Bristol & Exeter Railway. During the Second World War, a bomb put paid to the clock tower's wooden spire.

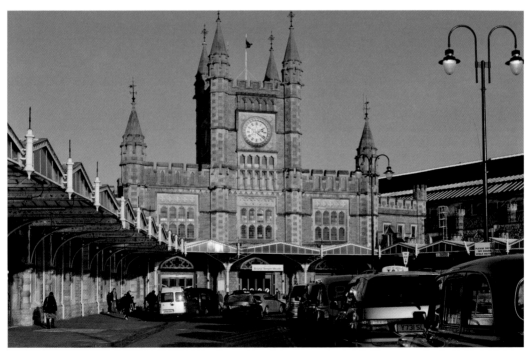

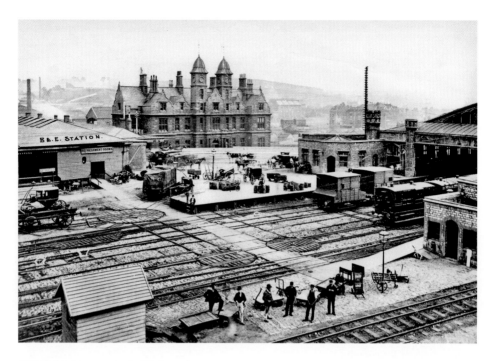

The Bristol & Exeter Railway

From 1845, the GWR shared Temple Meads site with the B&ER. This remarkable 1870 photograph, from the STEAM Museum of the GWR, shows the B&ER headquarters with the entrance to the GWR terminus on the right. The B&ER's tracks are at right angles to the GWR's, and in contrast to the grandeur of Brunel's terminus, their wooden building was irreverently known as the 'cow shed'. Although Brunel was also engineer to the broad gauge B&ER, the offices were designed by Samuel Fripp.

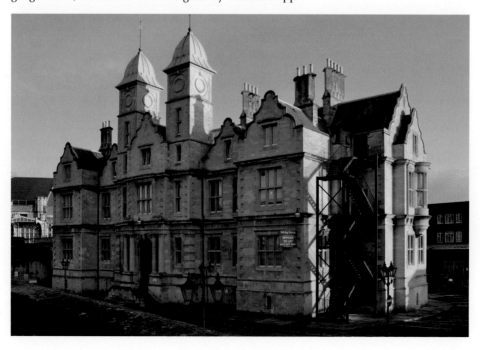

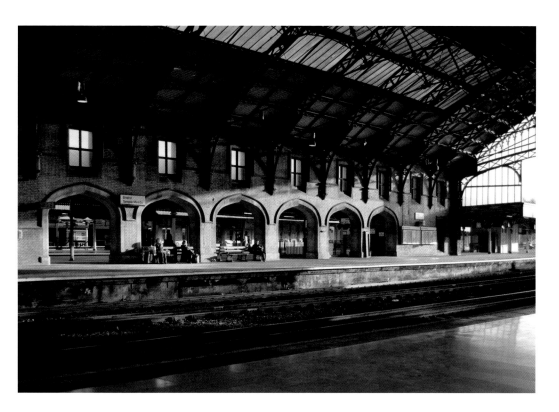

The new Temple Meads

Francis Fox's workmanlike designs for the enlarged Temple Meads of the 1870s featured a number of new through platforms to cater for increased train numbers, operated not only by the GWR but also by other companies with the spread of mixed-gauge track to the east and the eventual abolishment of the broad gauge in the 1890s. The new platforms followed the sharp curve of the mainline and they were covered by a glass roof of wrought-iron and wooden construction.

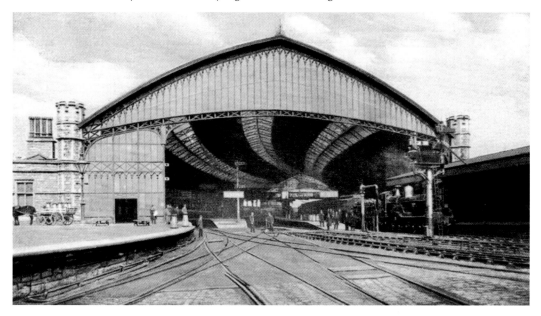

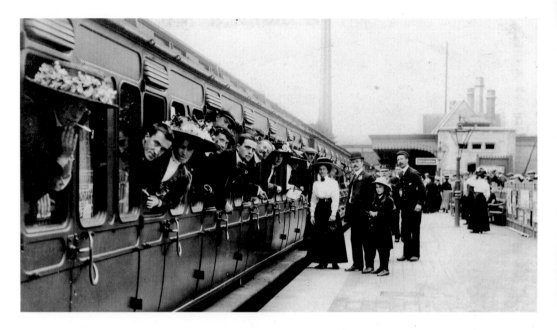

Stroud Station

In addition to the GWR's main route, a number of smaller lines branched outwards spreading the broad gauge network throughout the South West and into South Wales. The Cheltenham & Great Western Union Railway, which stretched from Swindon via Cirencester across to Gloucester, arrived in the Cotswold town of Stroud in 1845. IKB was engineer for the line and, although he had no particular enthusiasm for the project, the station at Stroud remains a fine example of the period.

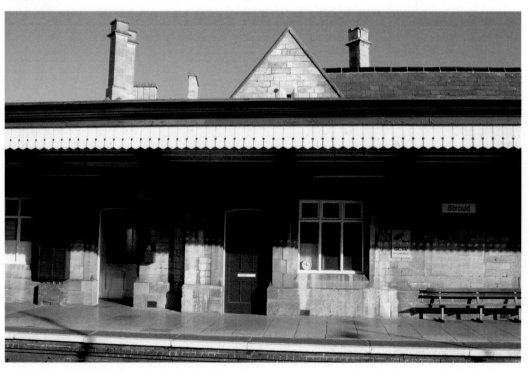

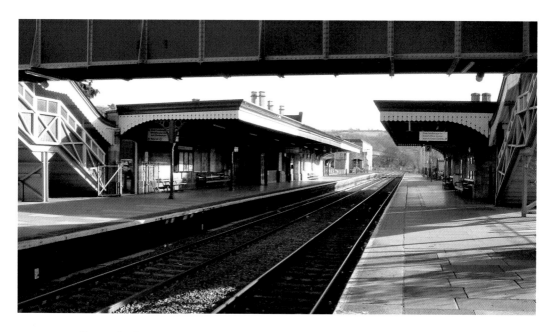

Stroud's goods shed

Beyond the end of the platforms at Stroud there stands a magnificent stone-built goods shed. Twin arches on the eastern or railway end, one now squared-off and held aloft by a steel joist, provided access for trains, while beneath its sturdy wooden-raftered roof a raised platform permitted the easy transfer of goods onto horse-drawn wagons. The slender two-storey building on the station side of the shed served as offices. Look out for the old GWR advertisement, which can still be made out, painted on the stonework along the side of the building.

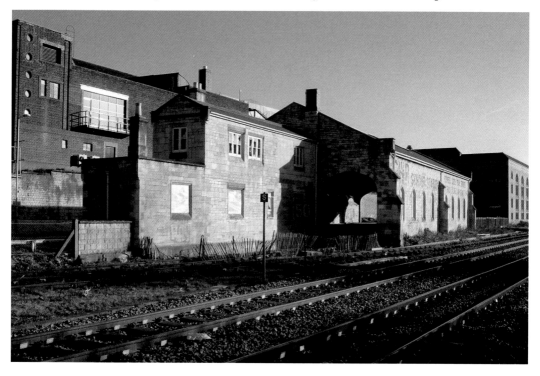

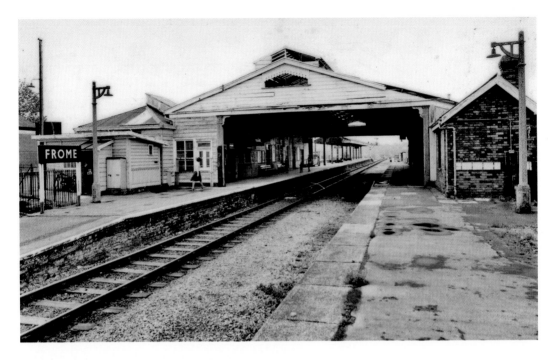

Frome and the Wilts, Somerset & Weymouth Railway

Opened in 1850, Frome's station is located on the eastern edge of this small town in Somerset. Originally, the WS&WR connected the GWR with Weymouth on the South Coast. Later improvements to the London to Penzance route, designed to shorten the journey and cut out Bristol, raised Frome's status on what became the main line to the South West during the early years of the twentieth century. This remarkable survivor from the broad gauge era is still a viable working station, currently on a loop linking the London to Penzance and the Bristol Weymouth lines.

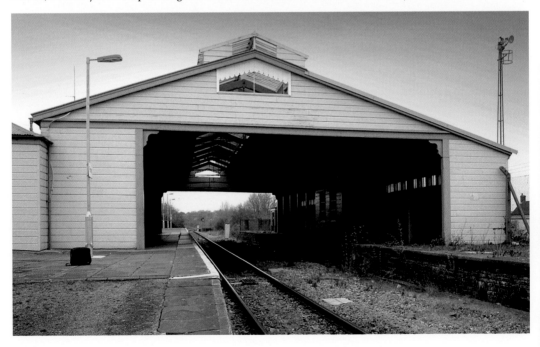

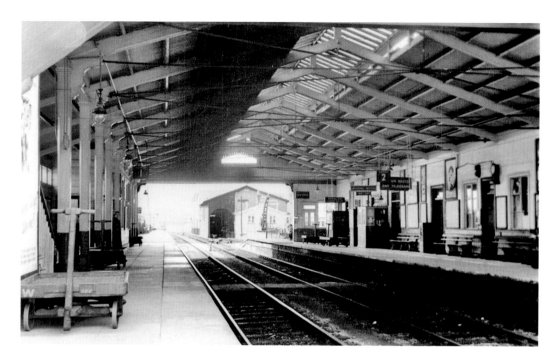

Frome Station

Although Brunel was engineer for the WS&WR, the wooden station building at Frome is probably the work of his assistant J. B. Hannaford. Painted in salmon pink, its all-over roof is still in remarkably good condition. The main difference nowadays is that the track has been reduced to a single line, and the far platform is no longer accessible to travellers. In comparison with the 1950s photograph, the platforms have lost their busy clutter, but more significantly, the wooden train shed visible just beyond the station has been demolished.

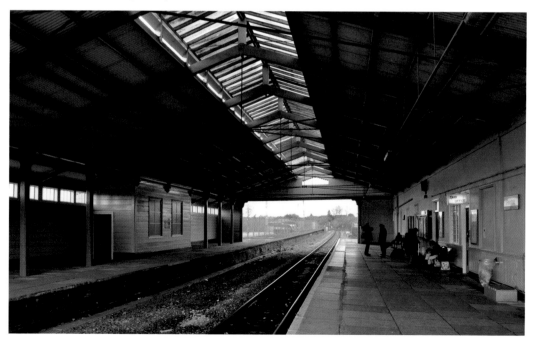

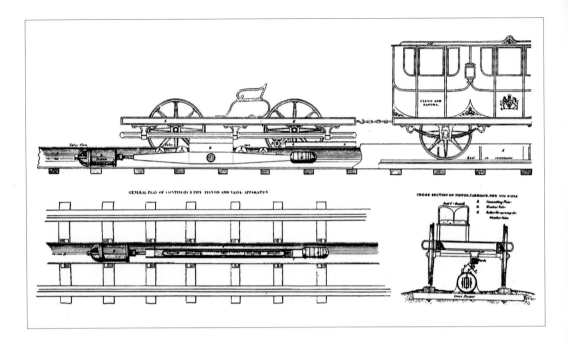

The railway with atmosphere

Never one to shy away from innovation, Brunel persuaded the directors of the South Devon Railway that atmospheric propulsion was the way to go. The principle was sound enough. The trains ran on conventional rails, broad gauge inevitably, with an iron pipe laid between them. A piston moving inside the pipe was sucked along by a vacuum created by a series of pumping stations, such as the one at Dawlish depicted in Nicholas Condy's painting. (Ironbridge Gorge Museum Trust)

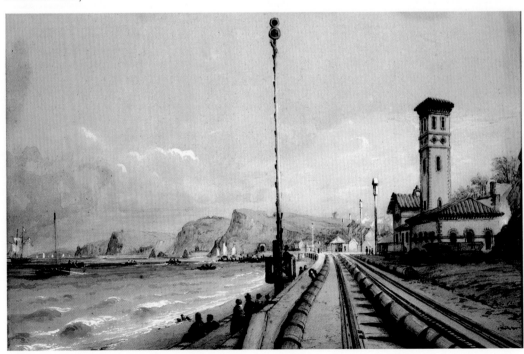

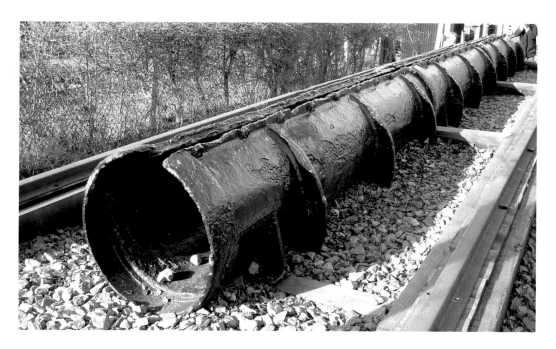

A short-lived experiment

The problem with the atmospheric system lay in the practicalities. The connection from the carriages to the piston passed through leather flaps, which tended to harden, resulting in a poor seal. Smearing them with grease attracted the rats, who ate the leather. Relics of the 'Atmospheric Caper' include a long section of the iron pipe displayed by the GWR Society at Didcot, and several of the pumping houses remain, including this one at Starcross.

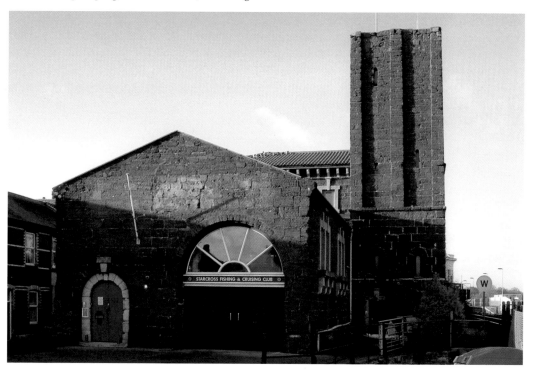

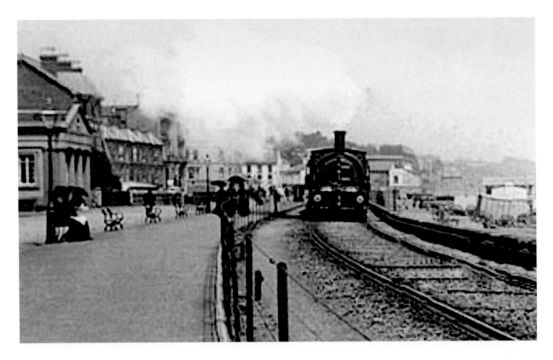

The South Devon Railway

Regardless of the merits of the atmospheric system, the route of the South Devon Railway, which connected Exeter and Plymouth, is one of the most picturesque imaginable as it follows the estuary of the River Exe and then hugs the red cliffs along the coast. But what modern planner would permit the building of a railway separating Dawlish from its beaches? In the photograph above, broad gauge trains are shown running through the town, but nowadays, the twentieth-century station buildings are in a shabby state.

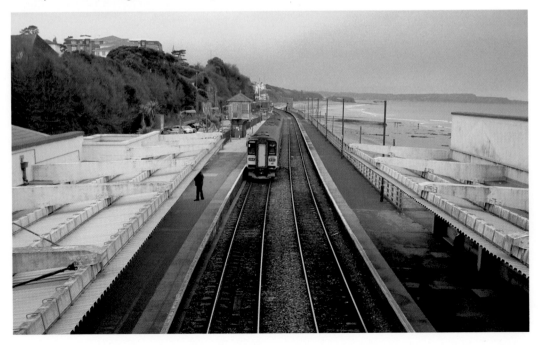

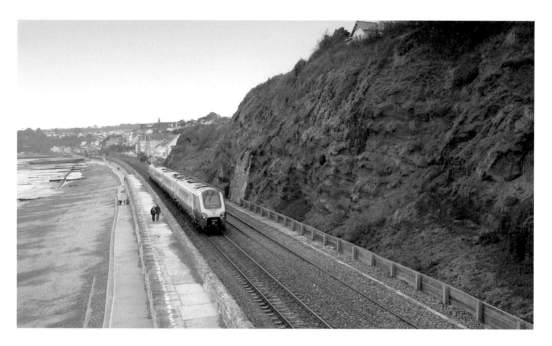

A train with a view

Extensive blasting of the cliffs was required to create a level terrace and sea wall for the railway between Dawlish (above) and Teignmouth. Trains pass through the headlands in a series of tunnels and this exposed stretch of line is notorious for the lashing it takes in bad weather. In 1855, the heavy seas swept away around 100 feet of track, leaving stranded passengers to clamber across the rocks on foot. By the 1930s, the GWR's publicity department readily exploited this 'picture postcard' scene in its advertisements for the famous Cornish Riviera Express.

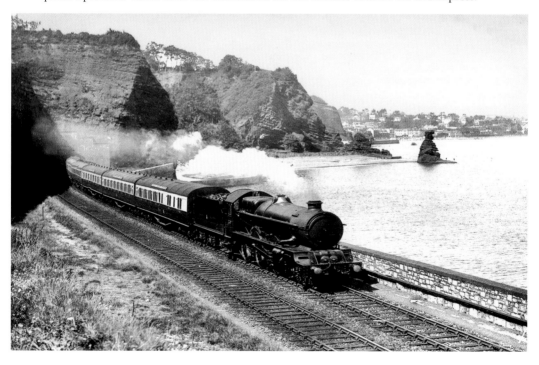

Bridges

A bridge represents the ultimate engineering challenge. It's the nearest thing to flying; cutting through the air with stone, iron and steel. There is no mystery to a bridge. All is exposed to full sight. There is no room for errors, no second chances if the first design doesn't quite work.

Of course, the route of the GWR had entailed a large number of bridges, and for the most part, these were of masonry or brick, the wide arches of the Maidenhead bridge over the Thames being a masterful use of the latter. Brunel also used other materials, such as wrought-iron girders for the bowstring bridge at Windsor, and wood for several bridges, including the Skew bridge at Bath. Wood would later serve him well when it came to constructing the many Cornish viaducts.

All of these examples of bridges are excellent in their own right, but it is the scale and grandeur of the big two, Clifton and Saltash, that are the ultimate expressions of engineering genius. These are Brunel's signature pieces. Looking upon the great humpbacked curves of the Royal Albert Bridge, perched high on their spindly piers, or the drama of the Clifton Suspension Bridge across the Avon Gorge, you can only marvel at the audacity of their conception.

Mention must also be made of Brunel's 'lost' bridges, the stepping-stones to Clifton and Saltash. Brunel himself regarded the Clifton bridge as his 'first child', but he had also been commissioned to design a suspension bridge to cross the Thames to provide access to the Hungerford Market. The Hungerford Footbridge was 1,462 feet long overall and consisted of three spans with wrought-iron chains passing over two masonry and brick towers in the Italianate style. It opened in 1845, but by the time of Brunel's death in 1859, the market site had been sold to the South Eastern Railway Company for the construction of their London terminus, and all but the piers were to be demolished for a new railway bridge.

Ironically, Brunel's Clifton bridge also ran into trouble, this time through a lack of funding, and the abandoned towers loomed like two stumps above the Avon Gorge until after his death. The project was revived by members of the Institute of Engineers as a monument to their former colleague, and as luck would have it, the iron chains from the Hungerford bridge became available at the right moment and were reused in Bristol. The Clifton Suspension Bridge opened in December 1864 and it remains the city's most recognisable landmark more than 150 years later.

Looking down from the bridge, towards the city, you can just make out a small iron swing-bridge which marks a new direction in

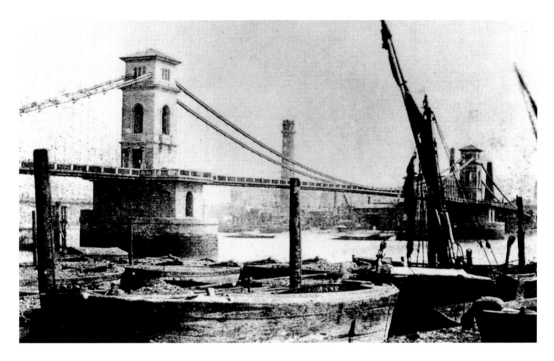

The Hungerford Bridge in London

Completed in 1845, the Hungerford Bridge was built to provide pedestrian access to the Hungerford Market on the north side of the river. Brunel designed its ornate towers in the Italianate style, as shown in the photograph by Fox Talbot. When the market was sold to the South Eastern Railway Company, to create Charring Cross Station, the bridge was converted to carry their trains. Only the red-brick and stone footings remain at this location, and 2002 saw the opening of the first of two footbridges, the Golden Jubilee Bridges, which now flank the rail bridge.

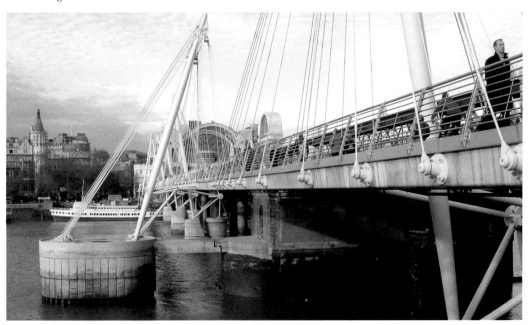

Brunel's designs. He was involved in a number of improvements to Bristol's floating harbour and docks, in particular creating a new south entrance lock from the river. In order to allow horse-drawn traffic to pass over this lock, he designed a small swing-bridge featuring circular top girders of wrought iron. His close friend, Robert Stephenson, had also proven the strength of this new material in box girder form with his Britannia Bridge over the Menai Straits. Brunel incorporated this principal when it came to designing a railway bridge over the River Wye at Chepstow. It was an awkward site with high cliffs on the eastern side, and softer low ground on the west, added to which, the Admiralty was demanding adequate clearance for its tall-masted ships. He devised a 'closed' structure in which the tendency of the suspension chains to pull the towers inwards was countered and contained by tubular top members. The Chepstow bridge was actually two bridges, running in parallel, with each carrying a deck on straight suspension chains. The main span was 300 feet wide, with a series of iron piers connecting three shorter spans to an embankment to the west. Opened in 1852, Chepstow's railway bridge was replaced in 1962 by an uninspiring modern structure; a great pity, as the old images reveal a striking design set in a very dramatic setting.

Chepstow was the test run for an even grander railway bridge over the River Tamar at Saltash. Once again, it was a challenging location with the same requirements for clearance, and Brunel devised a similar closed system, this time with two 465-foot spans, held aloft by masonry piers at either side and a single masonry and iron pier mid-river. The tubular top members were humped to mirror the curve of the suspension chains which, together with a series of vertical struts, supported the deck and a single-line track. In May 1859, Prince Albert travelled by train from Paddington to open the bridge named in his honour as the Royal Albert Bridge. Brunel had been too ill to attend the ceremony and died later that year. As a tribute to the great engineer, a simple epitaph was added to the portals at either side of the bridge. 'I. K. BRUNEL ENGINEER 1859.'

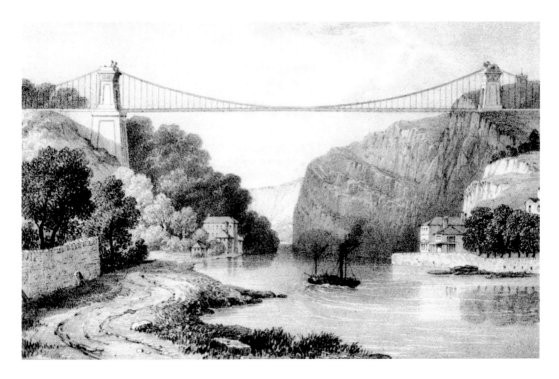

Designs on Clifton

It was the project to build a bridge across the Avon Gorge at Clifton that was to cement Brunel's relationship with Bristol and launch his meteoric career. The setting was spectacular and his early designs featured twin towers in the Egyptian style, each capped by a pair of sphinxes. A start was made in 1831, but a number of factors, mostly financial, meant it was not completed until after his death. As shown in the lower photograph, taken from the Rownham Ferry around 1910, the sphinxes never made it.

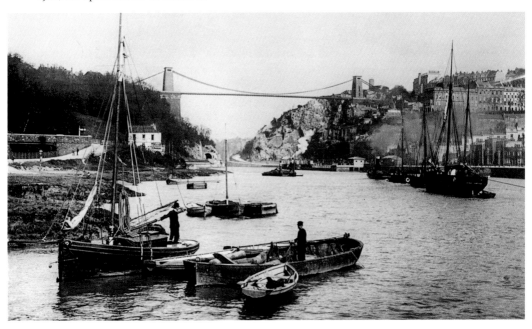

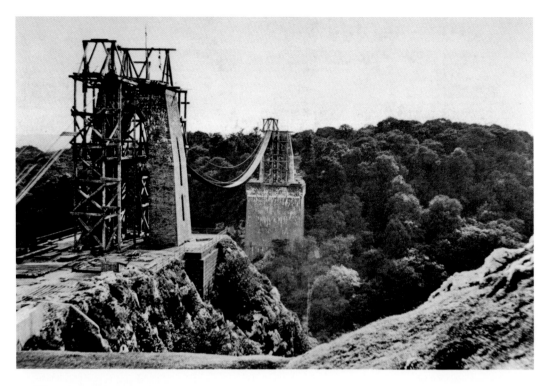

Building the Clifton Suspension Bridge
Left uncompleted for many years, construction resumed in 1862 as a tribute to Brunel, who died in 1859. This view from the Clifton side across to the Leigh Wood's abutment shows preparations for the installation of the chains. The bridge is slightly higher on the Clifton side, by about 3 feet; a feature deliberately incorporated by Brunel in his design to make it appear level.

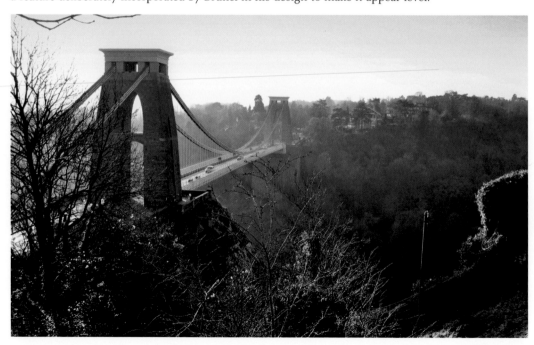

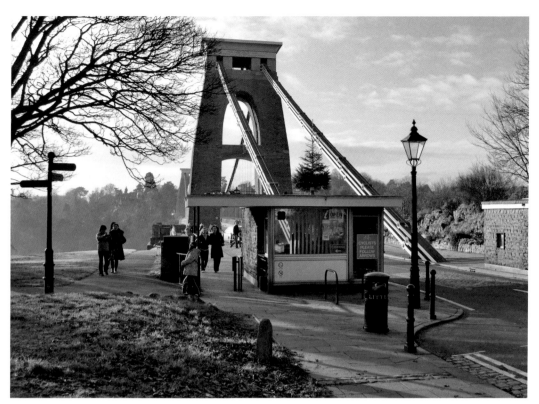

The opening ceremony

Amid much celebration, the Clifton Suspension Bridge was finally opened on 8 December 1864. Brunel never saw its completion and in its details it varied in many ways from his design. Apart from the addition of the bridge keeper's hut, it has little changed in the last 150 years. It is estimated that around 3,000 commuters use it daily, and the bridge carries 4 million cars every year. The modest toll charged to motorists covers the upkeep of the bridge, while pedestrians and cyclist have crossed free of charge since 1991.

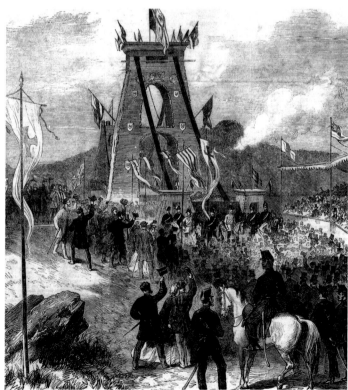

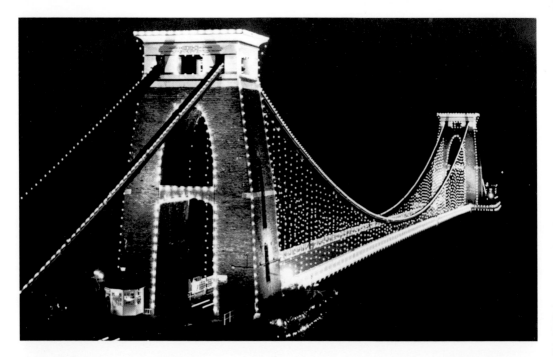

Clifton lights

The Clifton Suspension Bridge Trust was founded by Parliament in 1952 to care for the bridge. One of their first acts was to install thousands of light bulbs to commemorate the coronation of Queen Elizabeth II the following year. The lights stayed, and in 2006, on the 200th anniversary of Brunel's birth, a new system was switched on. This consists of 3,000 LEDs along the length of the chains, with florescent tubes illuminating the walkways, and floodlights on the towers and abutments. Energy efficient, it is said to use no more electricity than a detached house.

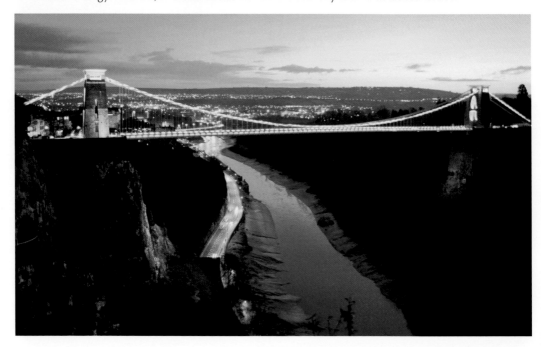

Chain reaction

By the time construction was resumed at Clifton, its iron chains had already been sold for the Royal Albert Bridge at Saltash. It so happened that Brunel's Hungerford footbridge was being dismantled to make way for the railway and in turn its chains were brought to Clifton. A third top row was added for extra strength. The chains pass over the towers, riding on saddles, and then down into excavations 60 feet deep. Originally wedged in by Staffordshire brick in-fills, since the 1920s, they have been anchored in 20 feet of solid concrete. Beside the bridge, a plaque commemorates the 100th anniversary of Brunel's death.

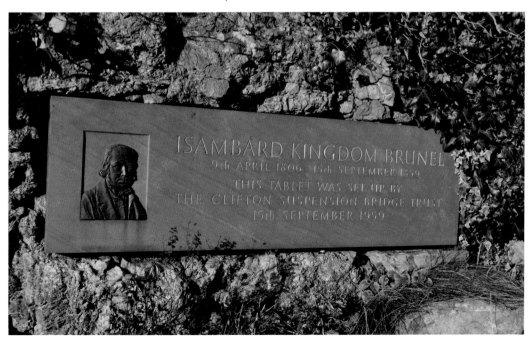

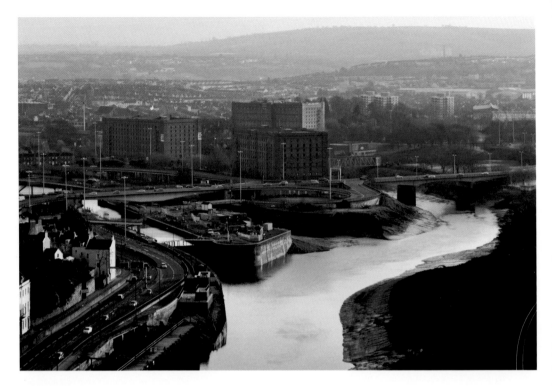

Bristol docks

Brunel was involved with a number of alterations to the docks, in particular improving the flow of water in the Floating Harbour and the construction of the South Entrance Lock for the Cumberland Basin. Looking down from Rownham Hill, the Avon is channelled into the New Cut on the right, Brunel's lock is central, and the newer north lock is on the left. Obvious modern additions include the bonded warehouses and the busy A3029 Brunel Way and the Plimsoll swing bridge. The photograph below is from around 1910.

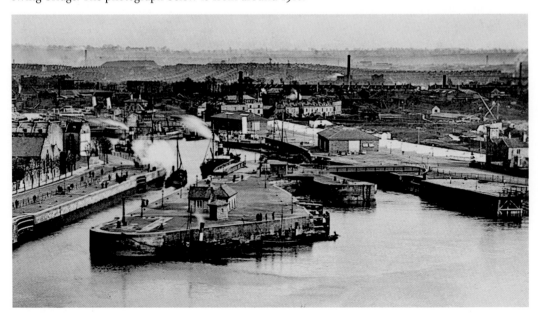

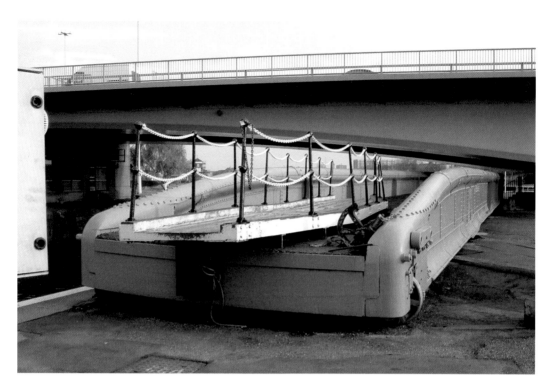

Brunel's swing bridge at Bristol docks

To pass over his new South Entrance Lock, Brunel designed a simple swing bridge featuring tubular wrought-iron girders – the direct predecessor to the bridges at Chepstow and Saltash. Just to confuse historians, in 1873, the original Brunel bridge was moved to the new north lock, as his lock was no longer used, and later a replica was put over the Brunel lock.

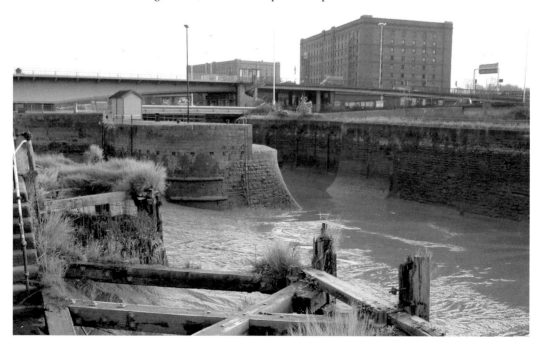

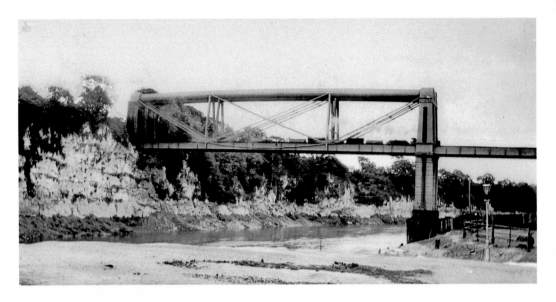

The railway bridge at Chepstow

Getting the South Wales Railway over the River Wye into Chepstow presented a particular problem, with high cliffs on one side and soft low ground on the other. The Admiralty had insisted on a 50-foot high-water clearance for ships, so a conventional arch was out of the question. Brunel's solution was a form of 'closed' suspension bridge which confines the stresses within its own structure. For the main 300 span, the deck is suspended in three sections on straight chains with the towers braced by tubular cast-iron top members, in essence box girders. On the Chepstow side, the track deck was supported on iron columns before joining an embankment.

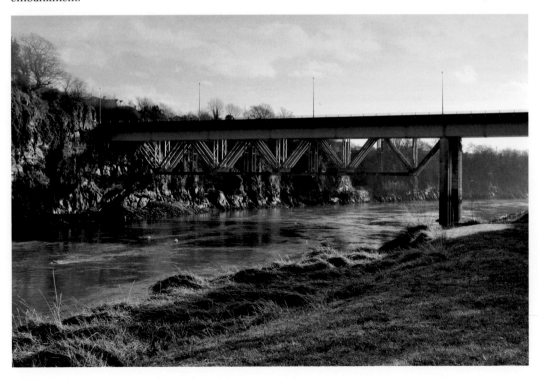

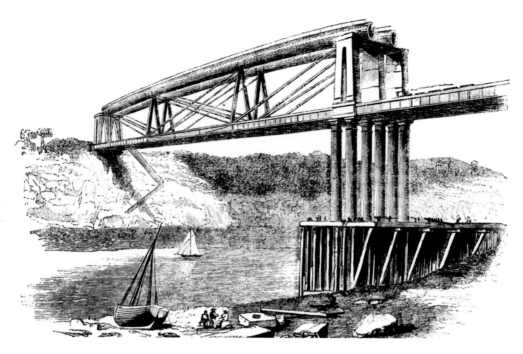

A rehearsal for Saltash

Although not obvious when seen from the side, the Chepstow railway bridge took the form of two parallel structures. The first line of track was operational by July 1852 with the other completed the following year. Unfortunately, Brunel's belt and braces bridge was unable to cope with modern railway loads and it was replaced with a steel girder bridge in 1962. Note the modern A48 road bridge which obscures the view of the rail bridge from the north side.

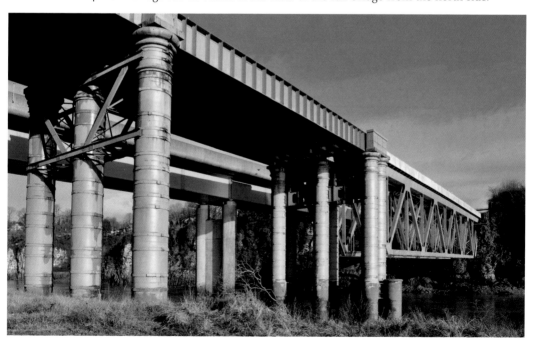

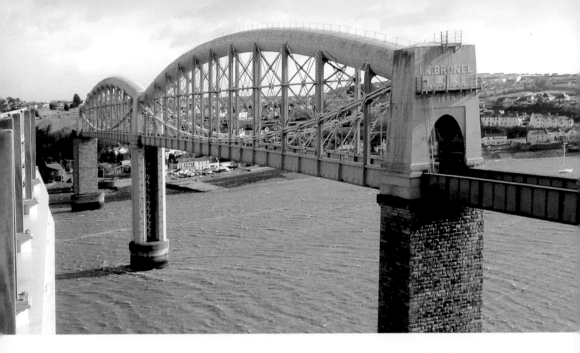

The Royal Albert Bridge at Saltash

The Tamar presented a considerable barrier to the railway's westward progress into Cornwall. Brunel devised a spectacular bridge featuring twin spans with a single mid-river pier, approached via a series of masonry piers on either side. The two humps, tubular iron box girders, are oval in cross-section to reduce cross-wind resistance and permit the deck struts to hang vertically. Mirroring their curves like bowstrings are the suspension chains which had originally been intended for the Clifton Bridge.

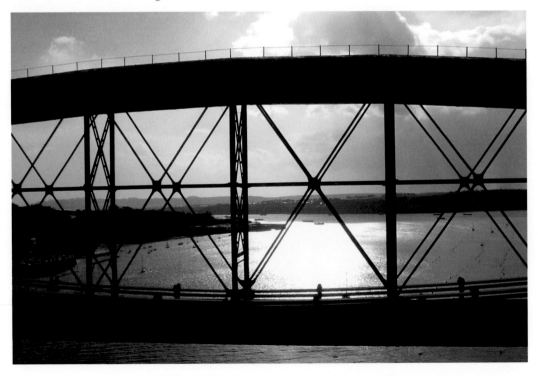

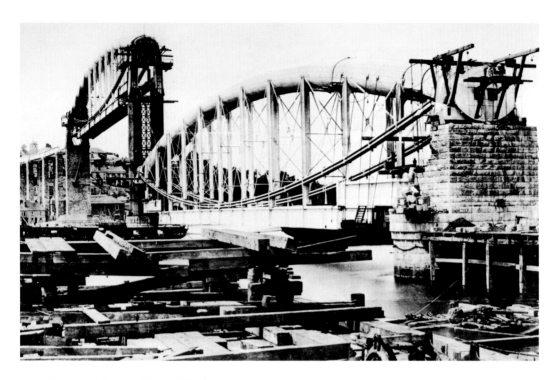

Constructing the Saltash Bridge

Each truss weighs 1,000 tons. They were constructed on the Devon shore and floated into position on pontoons. Brunel took command of the operation to move the first one, standing on a platform on the top accompanied by a band of flag-waving signallers to convey his orders. It was then slowly raised, 3 feet at a time, on hydraulic jacks as the cast-iron sections of the central pier, and the stonework of the Cornish pier, were built up.

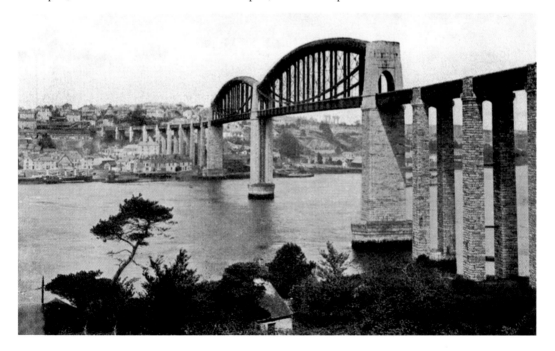

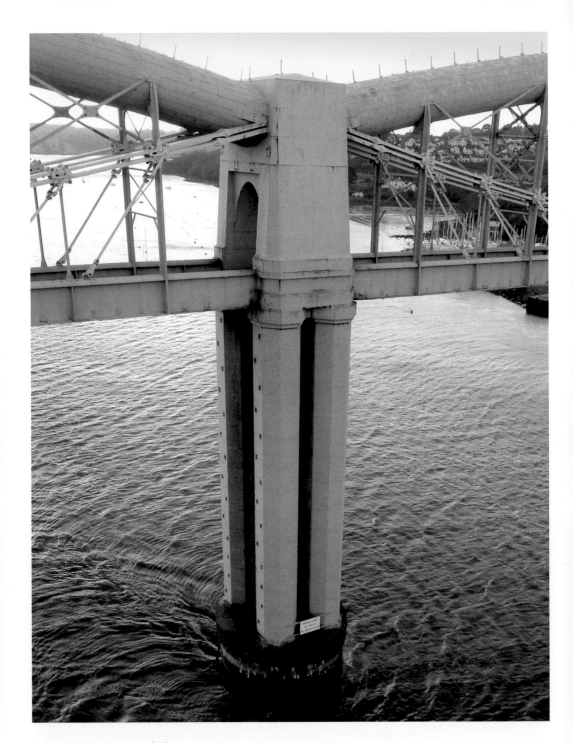

Saltash Bridge's central pier
The central pier consists of four octagonal cast-iron columns rising 96 feet above the water, and a masonry column descending an equal distance down to the bedrock. Construction was achieved by sinking a 35-foot cylinder to the riverbed to create a huge diving bell where the stone masons could work.

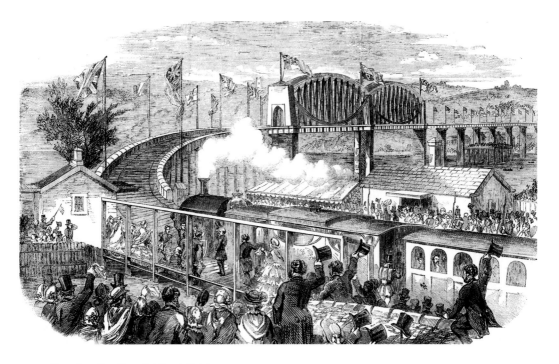

Opening the Royal Albert Bridge

In May 1859, Prince Albert travelled down from Paddington by train to open the bridge, now named in his honour. Brunel had been too ill to attend the opening ceremony, and shortly afterwards, he was taken across the bridge in an open carriage drawn by a broad gauge locomotive. Following his death, the directors of the Cornish Railway added a simple epitaph to the portals at each end of the bridge, 'I. K. Brunel Engineer 1859'.

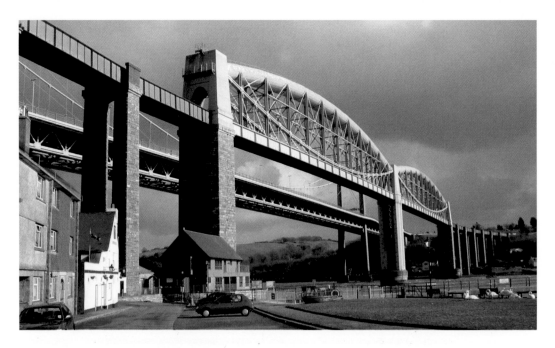

Royal Albert Bridge and Saltash Station

Brunel's Saltash bridge, with its single railway track, remains in constant use to this day and has been little altered apart from further strengthening work, including the addition of diagonal braces and tie rods, plus replacement cross girders and steel spans to support the deck. The most obvious new arrival on the scene is the 1961 Tamar Road Bridge, which, if nothing else, provides pedestrians with an excellent close-up vantage point from which to see Brunel's masterpiece. Sadly, the little station building at Saltash is in a much poorer state.

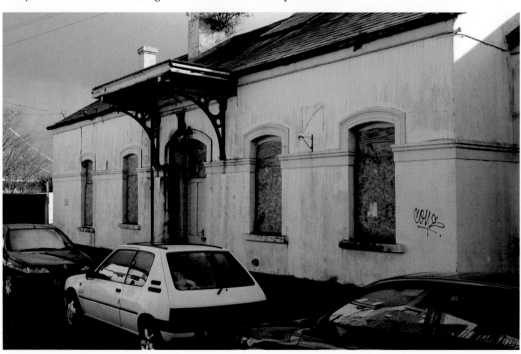

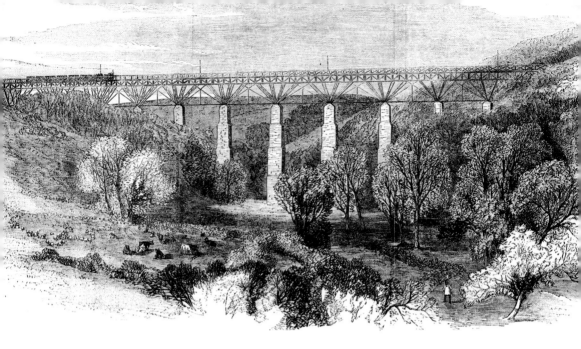

Brunel's wooden viaducts

Once into Cornwall, Brunel was faced with hilly terrain with a large number of deep valleys on the route to Truro. With limited finances, he constructed a series of viaducts, more or less to a standard design, with tall masonry piers and fan-like timber supports. Travelling west, the first of these is to be found at Menhenoit, just to the north of the A38 at Lower Clicker. In this example, the wooden section has been replaced by extensions to the original piers and capped with steel girders and deck.

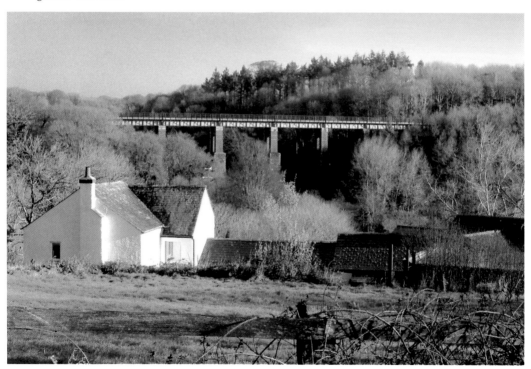

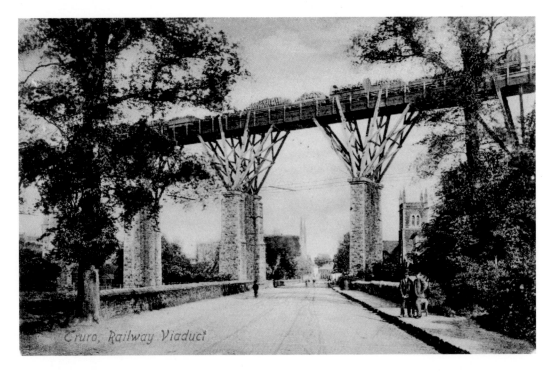

Truro, Railway Viaduct

The Cornish viaducts

This postcard from around 1900 shows a goods train running on the Carvedras Viaduct across St Georges Road in Truro. On these viaducts, the masonry piers were capped with iron plates and the heavy Baltic pine timbers supported longitudinal beams beneath the deck. The high viaducts were not popular with nervous travellers, especially on a dark stormy night. The highest viaduct, at St Pinnock, was 151 feet high with a length of over 600 feet. Shown below is a close-up of the masonry extensions on the Menheniot viaduct.

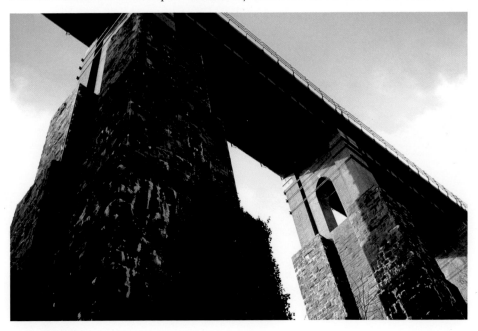

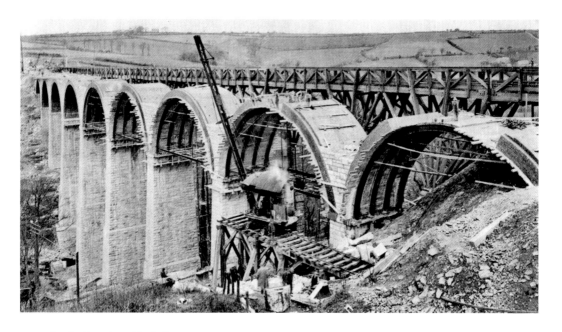

Replacing the old viaducts

When it came to updating the viaducts, it was not always appropriate to extend the existing structures, and in many cases, new all-masonry viaducts were constructed alongside. The new Ponsanooth viaduct is shown during construction, while the old one continues to carry the track. At Moorswater, the original arched and buttressed piers stand like a row of broken teeth in the shadow of their replacement.

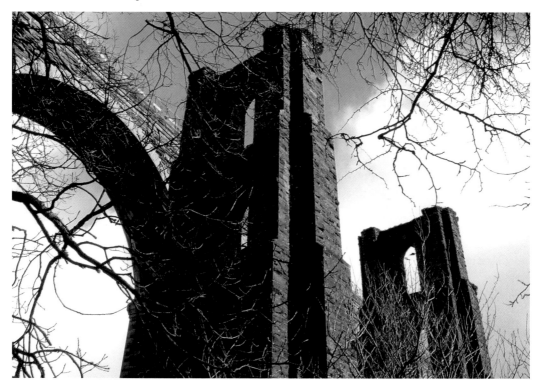

Steamships

Today, the idea of the high-profile engineer has largely given way to teams of highly specialist experts. The world of Brunel could not have been more different. It was considered perfectly reasonable for him to dip into a wide range of engineering disciplines. The fact that he had never designed a ship of any kind was of no consequence. After all, he was the greatest engineer of his times.

It is said that Brunel got into the ocean liner business as the result of a throwaway remark made at a meeting of directors of the GWR. Responding to a comment concerning the inordinate length of the railway, he said, 'Why not make it longer, and have a steamship go from Bristol to New York?' Apocryphal or not, the result was the formation of the Great Western Steamship Company in January 1836, for which Brunel was appointed engineer and William Patterson selected to build a ship at his yard in Bristol. At 212 feet, the *Great Western* was to be bigger than any vessel afloat, but in most respects, her oak hull followed traditional lines, albeit with additional longitudinal strengthening. Launched on 19 July 1837, and fitted with a pair of steam engines driving paddle wheels, she made her first transatlantic crossing the following April. The *Great Western* wasn't

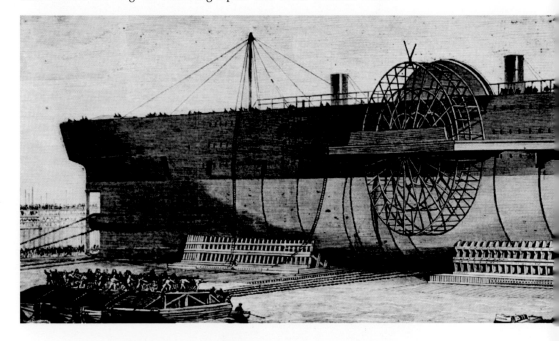

This contemporary engraving from *The Illustrated London News* shows the *Great Eastern* looming above the shipyard at Millwall.

the first steamship to reach New York, but she had vindicated Brunel's conviction that a sufficiently large ship was capable of carrying an adequate supply of coal.

The *Great Western*'s successor was to have been another paddle-driven wooden ship, originally to be known as *The City of New York*. However, when the *Archimedes* arrived on the scene in 1839, driven by an experimental screw propeller developed by Francis Pettit Smith, Brunel abandoned his paddles. The SS *Great Britain* was launched on 19 July 1843, and while her fine lines, lightweight iron hull and screw propeller pointed the way to the future, her seagoing career was a chequered one, including conversion as an emigrant clipper and, ultimately, she was abandoned at Sparrow Cove in the Falklands Islands.

Brunel's final ship, the *Great Eastern*, was a 'Leviathan' large enough to carry coal for the trip all the way to Australia. The ship was constructed at John Scott Russell's shipyard in Millwall on London's Isle of Dogs. It was a difficult build with a tumultuous relationship between engineer and builder, and it was an even more troublesome launch when she refused to budge on the slipways. Exhausted and in poor health, it proved to be Brunel's final project. He collapsed shortly after posing for a photograph on deck, and died a few weeks later on 15 September 1859 at the age of fifty-three.

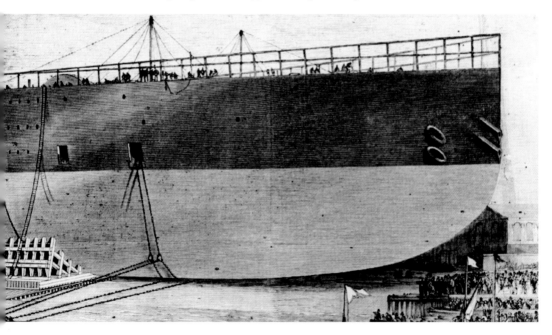

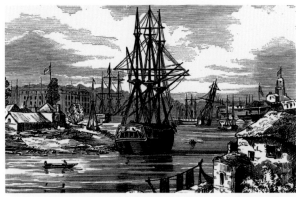

The *Great Western* steamship
Brunel's first ship, the *Great Western*, was launched in July 1837. Built by William Patterson in Bristol, it was the biggest ship afloat at 212 feet long, and although its oak hull was built along largely traditional lines, Brunel had carefully calculated that it carried sufficient coal to drive the paddle wheels all the way to New York. A plaque marks the site of Patterson's shipyard, which is now occupied by later dock buildings to the south of the Prince Street Bridge. In the engraving looking towards St Mary Redcliffe, her stern can be seen in the shipyard to the right.

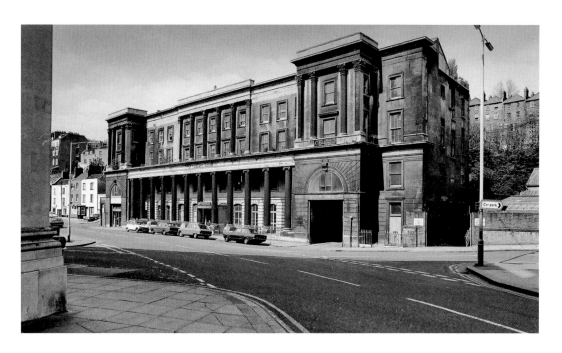

Transatlantic dreams

Designed by R. S. Pope in collaboration with Brunel, the Great Western Hotel was designed to accommodate passengers between their arrival by train and departure to New York by steamship. Situated in St George's Street, just behind the Council House building, it was looking neglected in this 1970s photo, but more recently, it has been given a facelift and now serves as offices. Originally, the horse-drawn carriages would enter and leave the rear courtyard via archways at each end, but the far archway has now been incorporated as part of the building.

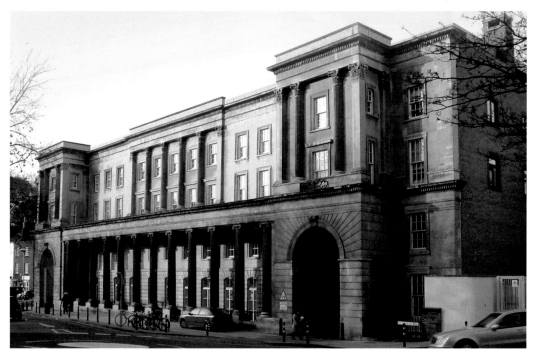

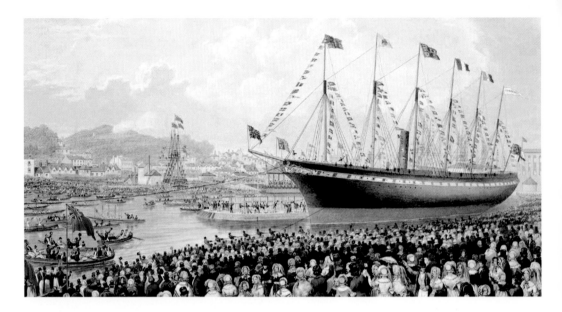

Launching the SS *Great Britain*
On 19 July 1843, thousands of spectators thronged to the docks at Bristol to see the launch of Brunel's latest steamship, the SS *Great Britain*. With a hull of iron and a revolutionary screw propeller this vessel was to define the shape of modern shipping. Following a chequered career as a transatlantic liner and later as an emigrant steam clipper on the Australian run, she has returned to her original birthplace in the Great Western Dockyard in Bristol. Beautifully restored she is decked in the flags worn on the day of the launch.

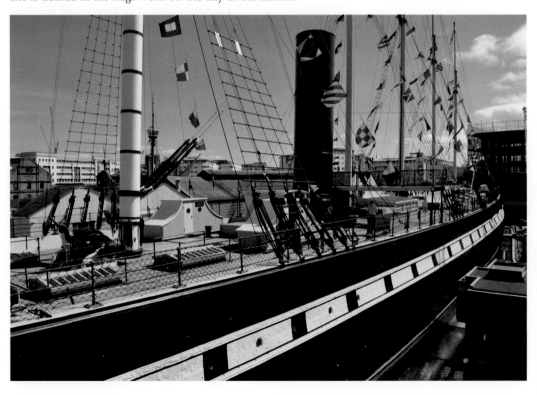

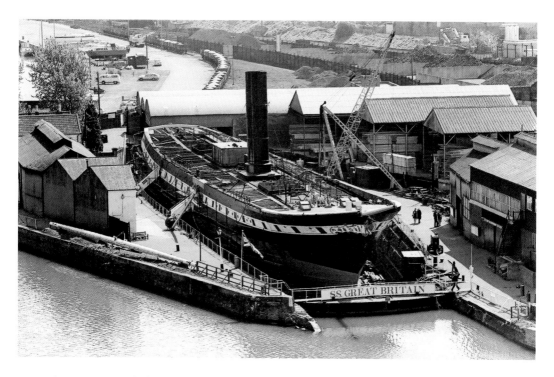

The SS *Great Britain* in dry dock
The dry dock at the Great Western Dockyard was purpose-built for the SS *Great Britain* and it fits like a glove. Since the upper photograph was taken in the 1970s, the old industrial buildings have been replaced by countless trendy apartment blocks crowding in around the ship.

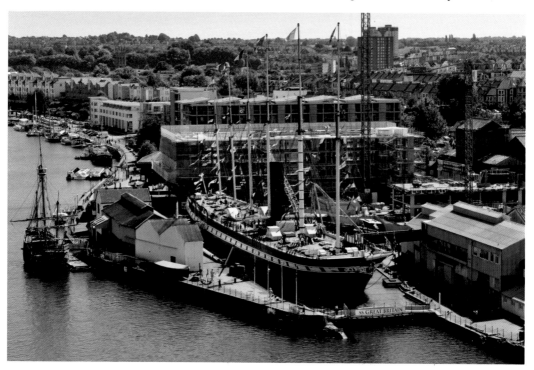

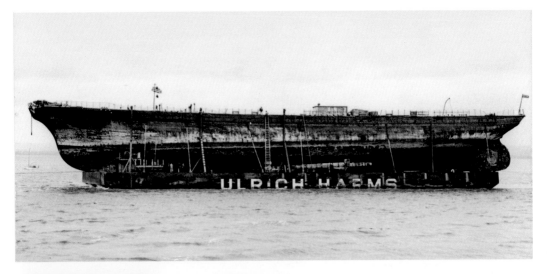

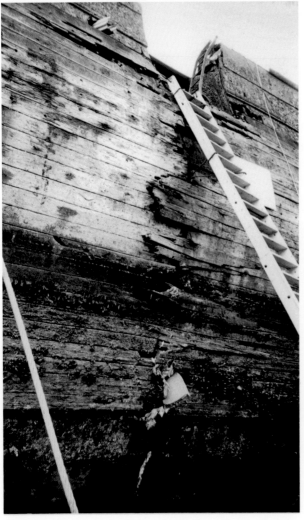

Recovering the SS *Great Britain*

Perhaps the most amazing aspect of the SS *Great Britain*'s story is her recovery from Sparrow Cove, in the Falkland Islands, where she had been abandoned in the 1930s. Transported across the Atlantic on a pontoon, the ship arrived back in Bristol on 19 July 1970, exactly 127 years to the day since her launch. The hull had been clad with wood during the latter part of her career, but this did not conceal a 13-inch crack running down her side. Clearly she would never be seaworthy again, but Brunel's iron ship had been saved from a slow death by rust.

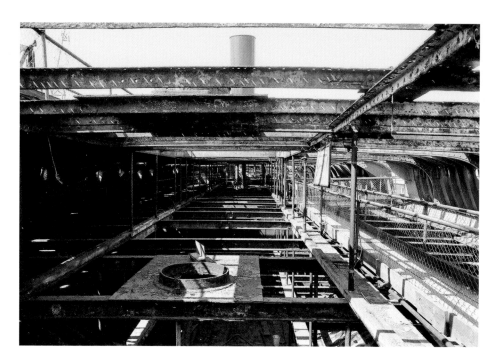

Back to basics

Stripped of her cladding and other wooden components, including the decking, the SS *Great Britain* was reduced to a bare shell. The initial task was to protect her from the elements with a new weather deck, and these photographs, taken in the mid-1970s, show the replica funnel poking upwards above the skeleton of the lower decks. In addition to stabilising the hull from further deterioration, the decision was taken to refit the ship to create a major tourist attraction, but it was going to be a mammoth task.

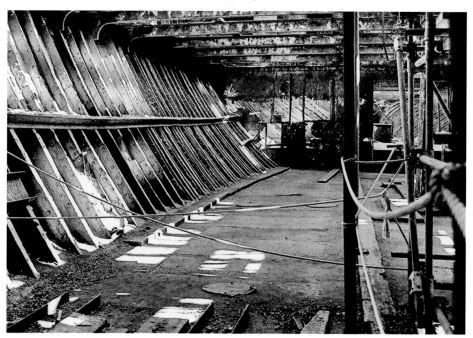

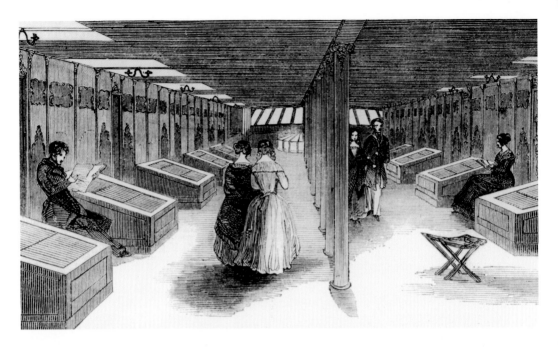

The promenade saloon

Just as with a modern luxury liner, the SS *Great Britain* was provided with suitably stylish facilities for the wealthy passengers who had paid to travel first class. The promenade saloon was a public area where they could walk or socialise whatever the weather conditions on the weather deck. The doors to either side led off to the first class cabins, and skylights between the doors carried light down to the dining saloon on the deck below.

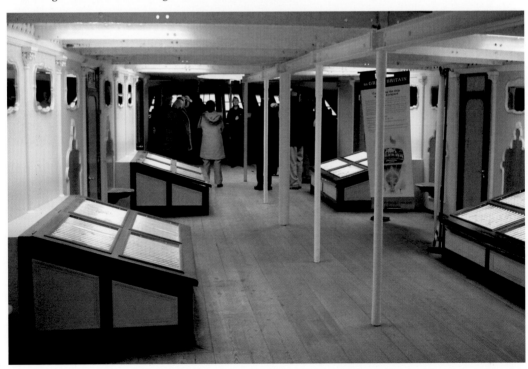

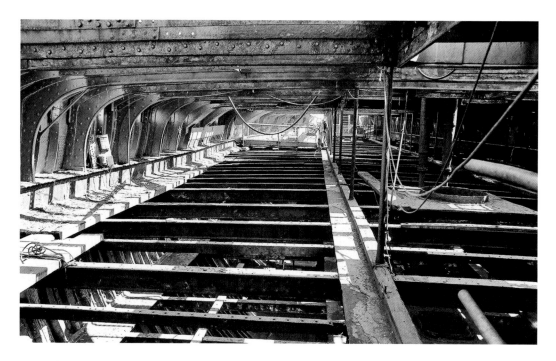

The dining saloon

Situated directly beneath the promenade saloon is the first class dining saloon. Beautifully recreated amid the bare bones of the ship, it features long tables with special benches that have hinged backs in order to face the table at mealtimes or into the central space during entertainments.

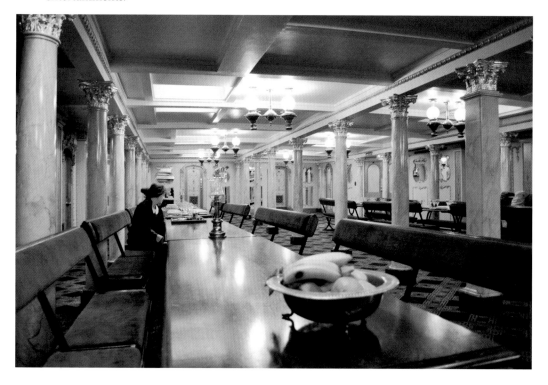

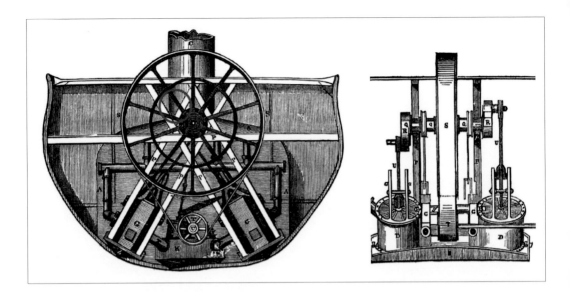

Steam power

At the heart of the ship was a pair of huge steam engines. Inclined upwards at a 60-degree angle, they were of the inverted direct-action type with twin 88-inch piston cylinders developing 1,000 hp at 18 rpm. With a combined weight of 340 tons, they were connected by chain drive to the 26-foot-diameter primary gearwheel, which in turn was linked by four smaller chains to a secondary gearwheel near the keel. Located just behind the funnel, the engines and primary gearwheel occupied the full height of the ship and passengers observed their reassuring motion through a skylight on the weather deck. Replicas have been installed on the ship, and to help gauge their size, the control wheel shown below is indicated in red on the cross-section.

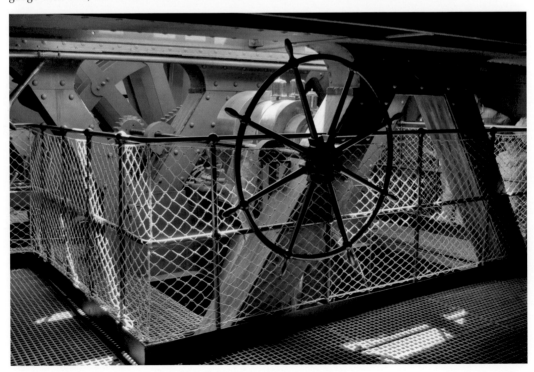

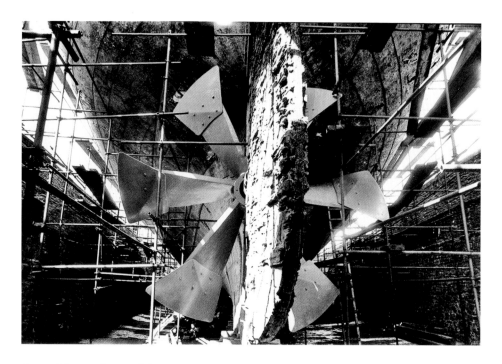

A novel form of propulsion

The SS *Great Britain* wasn't the first ship to have a propeller, but it was the first of any significant size. The propeller currently on view at the back of the ship is a replica of the original six-bladed design selected by Brunel after testing several designs. In the 1970s photo, you can see a wooden rudder which dates from later in her career, and this came back with the ship from the Falklands (now on display in the museum).

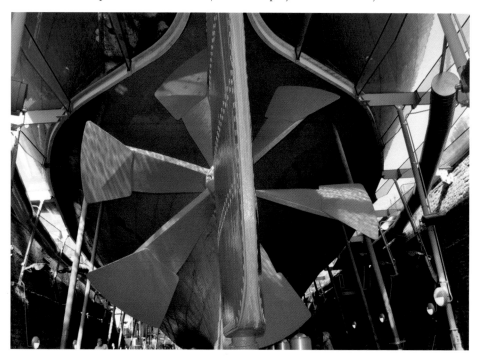

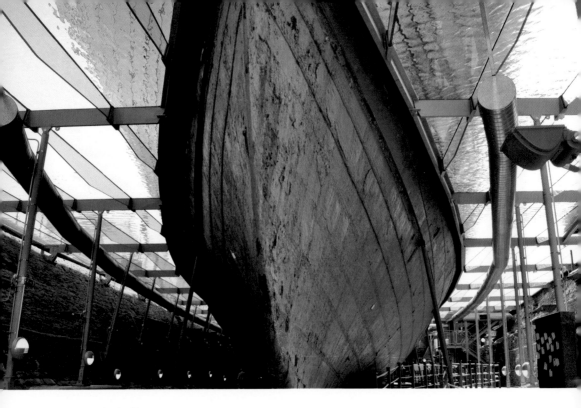

Preserving the hull

Rust is tricky stuff. After immersion in seawater for so many years, the ship's wrought-iron hull is impregnated with chlorides, which continue to draw moisture from the air. Unchecked, it is calculated that this insidious corrosion could have reduced the hull to a heap of rust within twenty years. Thankfully, the fitting of a glass-plate ceiling has created a controlled environment and dehumidification equipment removes 80 per cent of the humidity. Special anti-corrosion paints complete the protection.

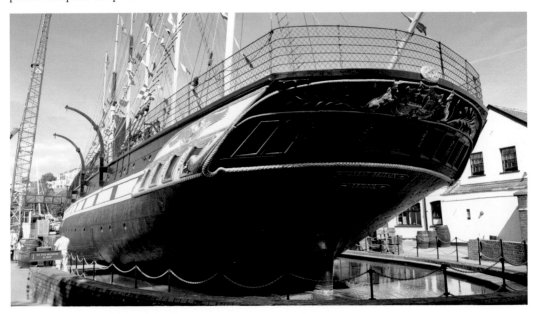

Wet and dry

The glass roof has been fitted at the water line and a thin layer of water completes the illusion that the ship is afloat in the dry dock. It creates an unusual opportunity to look up at the ship's prow from under the water. The vents for the dehumidifiers extend inside the lower hull and the forward hold section has been left unrestored to reveal the details of the iron hull plates. The forward bulkhead is visible towards the bows.

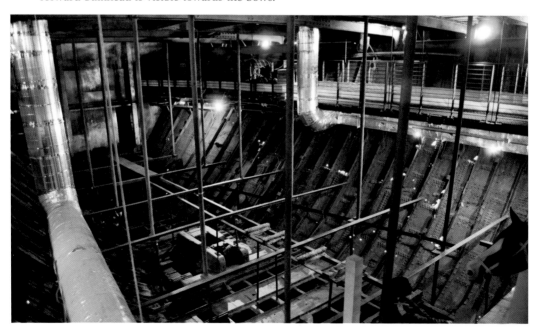

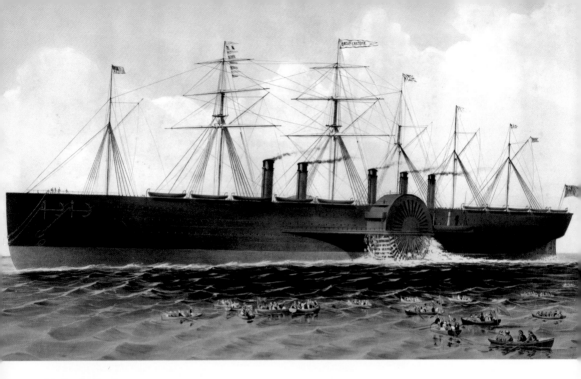

The 'Leviathan'

Completed in 1858, the 692-foot *Great Eastern* was the biggest vessel afloat and remained unsurpassed for more than forty years. But size brought its penalties. Built at Millwall, sideways to the Thames, she wouldn't shift at first and hydraulic rams were used to slowly push her into the water.

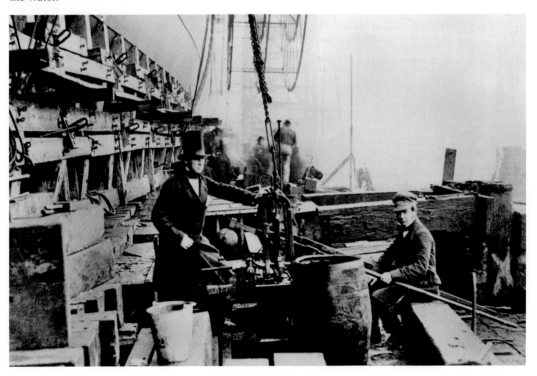

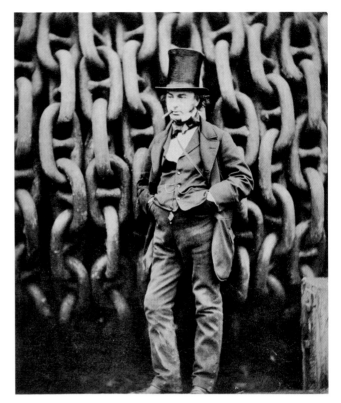

Launching the *Great Eastern*
Perhaps the *Great Eastern*'s most enduring legacy is this iconic photograph by Robert Howlett showing Brunel leaning against the massive chains on one of the checking drums. A chance photo, taken in a rare moment of calm at the climax of the engineer's tumultuous career, it remains a potent symbol of the 'Little Giant' with the big vision. The physical remains of his great ship are few and scattered, but at Millwall, on the Isle of Dogs, some of the hefty timbers from her slipway have been uncovered.

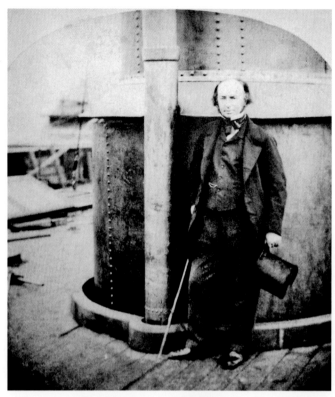

A final tragedy
Exhausted and in failing health, Brunel was photographed for the last time as he posed before one of the funnels of the *Great Eastern* two days before her maiden voyage. Moments later, he collapsed and was carried off the ship on a stretcher, and the ship sailed without him. In the English Channel, a feed-water heater at the base of the forward funnel exploded, and as a result, the blow-back of steam killed five stokers. In the lower picture, taken from a report in *The Illustrated London News*, the toppled funnel is shown lying across the deck.

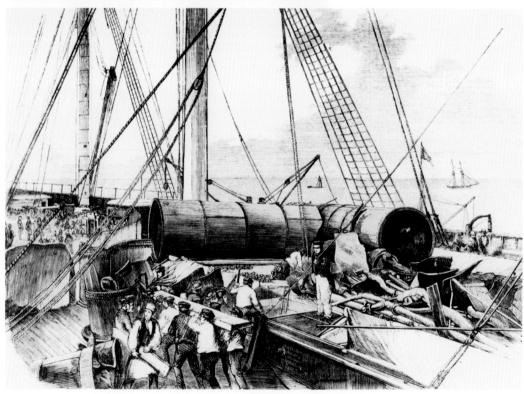

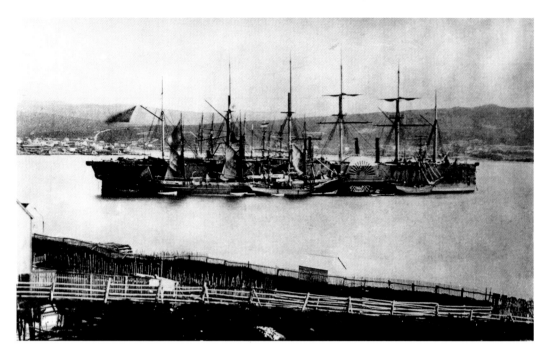

Relics of the *Great Eastern*

Above: The *Great Eastern* moored at Hearts Content, Trinity Bay, in July 1866. *Below*: One of the most unlikely relics to have survived from Brunel's last great ship is a piece of the funnel that exploded on the maiden voyage. When the ship put into Weymouth for repairs, this section was left behind, and for years, it was used within the town's water supply system. It is now displayed at the SS *Great Britain* museum, along with the ship's over-sized whistle.

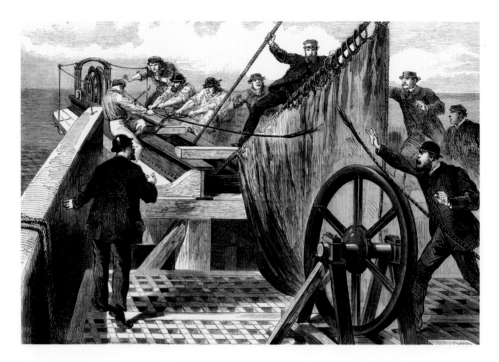

Laying the transatlantic cable

The *Great Eastern* only made a handful of trips as a passenger ship. Her greater claim to fame was as a cable-layer when she was chartered to the Telegraph Construction Company. The passenger accommodation was removed and the hull converted to house thousands of miles of cable. However, the first attempt to lay a transatlantic cable between Britain and the USA failed in August 1865 when the cable broke, shown above, but in July the following year, they succeeded.

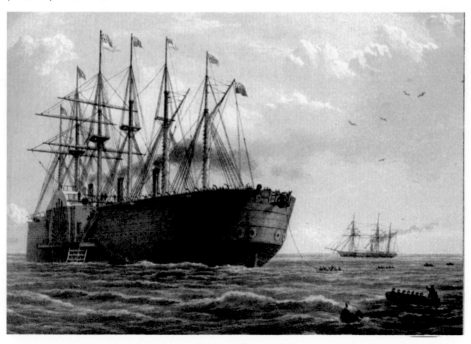

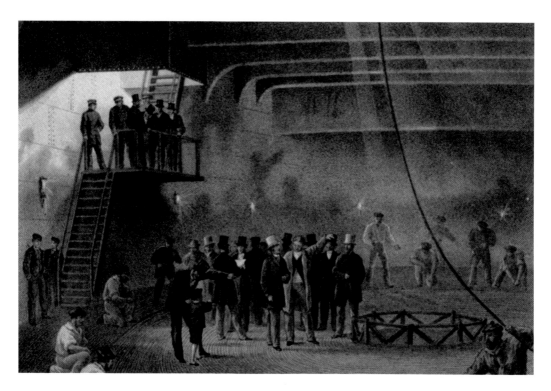

Sold for scrap

Following on from the transatlantic telegraph cable success, the *Great Eastern* was subsequently used to lay several other cables, linking France with the USA, Bombay with Aden, and up the Red Sea. When replaced by a custom-built cable-layer, she ended her days as a floating showboat and as an advertising hoarding anchored in the Mersey. In 1888, she was sold for scrap, and she is shown below awaiting her fate at the hands of the breakers.

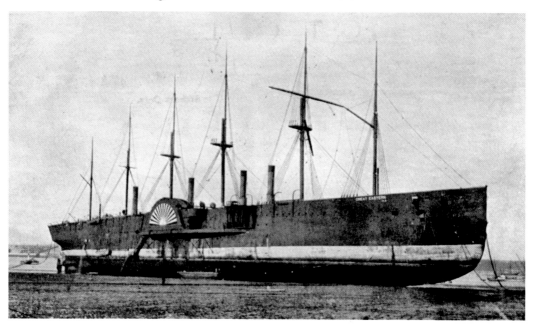

A contemporary cartoon, published in *Punch* in 1892, depicting the ghost of Brunel and the passing of the broad gauge.

Acknowledgements

I would like to acknowledge and thank the many individuals and organisations who have contributed to the production of this book. In particular, Campbell McCutcheon of Amberley Publishing for coming up with the idea of including this treatment of Brunel within the 'Through Time' format. A great excuse for me to revisit his greatest works once more.

Unless otherwise credited, almost all of the new photography is by me, or in some cases, by my wife Ute Christopher (who also assisted with proofreading), and also by our children Anna and Jay. My grateful thanks to them. I first discovered Brunel when I was a student in Bristol, in the mid-1970s, and at that time, I compiled a photographic survey of his work within the city. In 2006, I was fortunate enough to repeat this process, photographing at various locations across the country for a book marking the 200th anniversary of his birth, and more recently, I reacquainted myself with many of them for this publication.

Most of the historical pictures are from my own collection and for additional images I must thank the following: John Powell and Joanne Smith of the Ironbridge Gorge Museum Trust, Elaine Arthurs of the STEAM Museum of the Great Western Railway, Campbell McCutcheon, and also Runtheredline for the photograph of Sonning Cutting (it shows a Class 50 English Electric Type 4 loco by the way). Apologies to anyone left out unknowingly and any such errors brought to my attention will be corrected in subsequent issues. JC